IMAGES
of America

MIDDLETOWN
BOROUGH

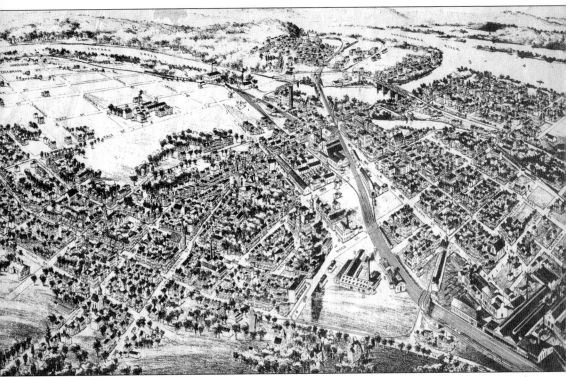

This 1894 map of Middletown, drawn by T. M. Fowler, shows Swatara Creek emptying into the Susquehanna River at the top (south) and Main Street running along the bottom (north) from left (east) to right (west). Notable building complexes include Keener's Press Brick Works in the upper left quadrant along Race Street, King's Middletown Car Works in the middle right off Main Street, and the American Tube and Iron Company in the lower right corner. (Courtesy of the Middletown Area Historical Society.)

On the cover: The southeast corner of Union and Emaus Streets around 1940 featured the Great Atlantic and Pacific Tea Company, which was advertised as "America's largest food service" and was more commonly known simply as the A&P. Next to it is the J. J. Newberry Company 5, 10, and 25¢ store, which was advertised as "where your money buys the most." They are in the Krauss or Rewalt (clothiers and a druggist, respectively, who previously occupied the site) Building, constructed shortly after the disastrous fire of April 9, 1910, which destroyed most of the downtown business area. (Courtesy of the Middletown Area Historical Society.)

IMAGES
of America

MIDDLETOWN
BOROUGH

David Ira Kagan and
Edward William Sunbery

ARCADIA
PUBLISHING

Published by Arcadia Publishing
Charleston SC, Chicago IL, Portsmouth NH, San Francisco CA

Printed in the United States of America

Library of Congress Control Number: 2008939953

For all general information contact Arcadia Publishing at:
Telephone 843-853-2070
Fax 843-853-0044
E-mail sales@arcadiapublishing.com
For customer service and orders:
Toll-Free 1-888-313-2665

Visit us on the Internet at www.arcadiapublishing.com

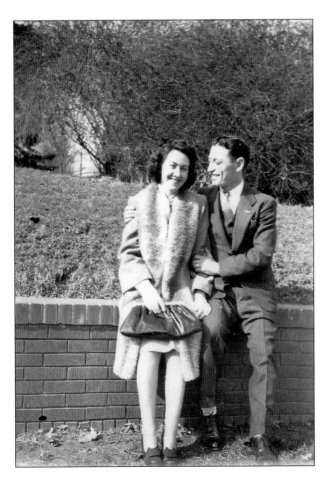

Edith Louise Hickernell Kagan (1917–2002) was a great-great-great-granddaughter of George Fisher, the founder of Middletown. She was the daughter of John and Grace Fisher Hickernell. She lived her entire life in the Middletown area. Here she is in March 1945 with Oshea Kagan (1915–2006), whom she married on September 1 of that year. He had a career working for Olmsted Air Force Base. This book is dedicated to them. (Courtesy of the family of Edith and Oshea Kagan.)

CONTENTS

ACKNOWLEDGMENTS

Most importantly, our sincerest thanks go to Grace I. DeHart for helping us to actually begin working productively on this book, providing us, from her own personal collection, with our first group of photographs of old Middletown for scanning. Furthermore, she allowed us to use information from her own book, the 1976 *Early Industries of Middletown, Pennsylvania*, in our captions.

A second major source of photographs was the large collection belonging to the Middletown Area Historical Society. President Bonnie Stazewski personally searched through the files and located a large number of images for us to scan, including those gathered together by trustee emeritus Leon R. Daly. Triscari Productions of Camp Hill, under owner Sebastian Triscari, prepared Daly's collection for us to meet Arcadia Publishing's specifications. Unless otherwise noted, images are courtesy of the Middletown Area Historical Society.

Joseph and Louise Sukle, the owners of Middletown's weekly newspaper, the *Press and Journal*, opened their archival photographs to us also. They allowed us office space and time one Friday to go through the collection and scan what we desired.

The Middletown Public Library was also invaluable to successfully completing this book. Librarian Barbara Scull accommodated us, meeting all our needs and guiding us to historical sources. Various library staff answered our questions and also directed us to information.

Middletown area residents, present and past, also provided us with information and photographs. Thank you to Jack and Shirley Ray Houser Bush, C. D. Farr, Sgt. Robert Givler, Hilda Hoke, Lawrence Kapenstein, Stefan Klosowski, Jean Kresge, Karl and Shirley Kupp Jr., Lila Lesher, Keith Matinchek, Mayor Robert G. Reid, Elwood C. Seiders, Stanley Singer, and borough manager Jeffrey Stonehill.

Finally, we want to thank our wives, Beth Kagan and Carol Sunbery, and our children— Rachel, Rebecca, and Sarah Kagan, and Ellen Sunbery Bowlin and Laura Sunbery Russell—for their love of us and our effort to preserve Middletown's and our own treasured past.

INTRODUCTION

Middletown's history really began in 1690 when William Penn published a proposal in London for a settlement "upon the river Susquehannagh." At the dawn of the 18th century, English and Irish settlers arrived, with the latter wanting to avoid religious persecution. It was not until 1755 that the town of Middletown (the oldest in Dauphin County) at the mouth of Swatara Creek where it empties into the Susquehanna River, which was previously the site of a Native American village, was finally laid out by George Fisher, the youngest son of John Fisher III, a Philadelphia merchant. John Fisher III's grandfather John Fisher I had come from England with William Penn on the initial voyage of the ship *Welcome* in 1682.

According to Charles Henry Hutchinson in his 1906 book *The Chronicles of Middletown*, after its founding, Middletown "grew rapidly and its trade soon exceeded any other town on the river. The immigration westward was large and continuous, and all passed through the town, Main Street being a part of the great highway, called the King's Highway [laid out in 1736], between Philadelphia and Pittsburgh." Middletown's name reflects the fact that it is halfway between Lancaster and Carlisle.

Important to the early community's religious life, Sant Peter's Lutheran Kierch was erected in 1767 on ground deeded by George and Hannah Fisher to George Everhart Frey "for the sum of seven shillings and sixpence, with the additional rental of one grain of wheat per annum payable on each consecutive 1st of May." Even today, a direct descendant of George Fisher receives the grain of wheat at ceremonies held in the old edifice.

Frey became the owner of much land in Middletown. He was one of early Middletown's leading citizens and was a merchant, miller, and philanthropist, in addition to being a landholder. His mill was the largest in Pennsylvania in the late 18th and early 19th centuries. His will provided for the erection and maintenance of a home for orphans, the Emaus Orphan House.

Very interesting historical notes exist about Middletown just prior to, during, and right after the Revolutionary War. On June 10, 1774, at a meeting in Middletown chaired by Col. James Burd, who was a prominent citizen of town and a veteran of the French and Indian War, a set of resolutions was passed condemning acts of the British parliament against the colonies as "unconstitutional, unjust and oppressive." Furthermore, the Middletowners resolved that it was their "indispensable duty to oppose every measure tending to deprive us of our just rights and privileges." This came more than two years before the Declaration of Independence in Philadelphia.

Colonial records for 1779 list Middletown as being a supply depot for the army during the war. Also in that year, the boats for Gen. John Sullivan's expedition against the Iroquois Indians in New York State were built in Middletown.

In October 1794, Pres. George Washington stopped at McCammon's Tavern on Union Street, the site later occupied by the Presbyterian church's manse. About 30 years later in 1825, another famous Revolutionary War figure, the Marquis de Lafayette, stopped at a different tavern in Middletown, the Pennsylvania House. It was located right next to the Farmers Hotel (today's Lamppost Inn) on East Main Street.

On February 19, 1828, Middletown became incorporated as a borough. In 1857, a community at the south end of Middletown on the west side of Swatara Creek where it joins with the Susquehanna River called Portsmouth (at first known as Harborton when it was laid out in 1809 by George Fisher Jr., the son of the founder of Middletown), consolidated with the borough of Middletown, becoming its First Ward.

On the east side of Swatara Creek where it joins with the Susquehanna River, a community called Port Royal was laid out around 1775. In 1892, its name was changed to Royalton. It has always been intimately associated with Middletown, connected by the County (or Grubb Street) Bridge, Aqueduct Bridge, and Pennsylvania Railroad bridge.

In the 19th century, Middletown gained important transportation links, adding to its advantage of already being fortuitously located along the Susquehanna River. In 1828, the Union Canal from Middletown to a point on the Schuylkill River just below Reading (a distance of about 80 miles) was completed. And at Middletown, it connected to the Pennsylvania Canal. The Union Canal carried traffic until 1885, when it was abandoned due to increasing competition by railroads. The Harrisburg, Portsmouth, Mount Joy and Lancaster Railroad was completed in 1836 and extended to Harrisburg by 1838, becoming a part of the Pennsylvania Railroad in 1846. By the early 1890s, another rail line up Swatara Creek from Middletown provided a link to Reading. Industries sprouted up in Middletown, taking advantage of the major road, canal, rail, and waterway intersections.

One of the more notable episodes in the history of Middletown's railroads occurred on April 20, 1865. Pres. Abraham Lincoln's funeral train passed through at 11:30 a.m. It was reported that several hundred of the town's citizens witnessed the passing of the nine cars covered with mourning drapes. A spruce arch over the tracks bore the inscription "For Freedom Fallen."

The first town newspaper was the *Argus*, an independent, family journal established by a Mr. Wilson in 1834 but then discontinued in 1835. In 1851, H. S. Fisher began publishing the *Central Engine*, which became J. W. Stofer's *Swatara Gem* in 1853, the *Dauphin Journal* in 1856, and finally the *Middletown Journal* in 1870. In 1890, A. L. Etter added a *Daily Journal*. Also, J. R. Hoffer had started the *Press* in 1881. This farm and public sale newspaper was purchased in 1944 by the *Middletown Journal*, and the *Press and Journal* was born.

In 1917 during World War I, the U.S. Army Air Corps depot was built at the west end of Middletown by the railroad tracks. In 1923, it was renamed Olmsted Air Force Base, and by 1930, it had over 300 civilian employees, becoming the largest employer in the area with over 11,000 workers when it was decommissioned in the mid-1960s. In 1966, part of the base (on the north side of the main highway into town from the west) became the Capitol Campus of Pennsylvania State University. The airport associated with the old base remained for nonmilitary use, eventually becoming the Harrisburg International Airport of today.

In 1972, flooding in the aftermath of rains associated with Hurricane Agnes inundated Royalton and Middletown's First Ward along Swatara Creek and the Susquehanna River. An accident at the Three Mile Island nuclear plant on March 29, 1979, nearly ended in what would have been a disastrous meltdown. The incident certainly gave the community worldwide notoriety. The Middletown quarter-millennial celebration (250 years) was held on August 7, 2005. At a service of thanksgiving held in old Sant Peter's Lutheran Kierch, six longtime Middletown residents—Leon Daly, Margaret Kern, Dale Rider, Stanley Singer, Hilda Hughes, and Richard Swartz—spoke, reflecting on all the positive aspects of their lives in Middletown, a community that began in the mind's eye of William Penn.

One

INDIVIDUALS AND GROUPS

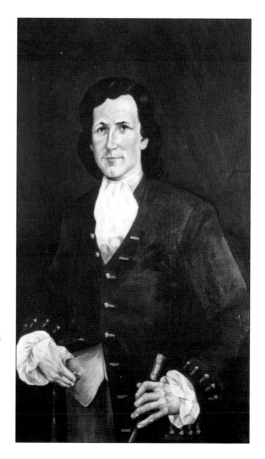

This is a portrait of George Fisher (1732–1777), the founder of Middletown in 1755. Fisher farmed and raised two sons and a daughter with his wife, Hannah Chamberlain (1740–1777). In 1777, when some travelers became ill, the Fishers, known for their charity, took them in and cared for them, but they died. Both George and Hannah contracted the disease and died within a few hours of each other on February 21, 1777.

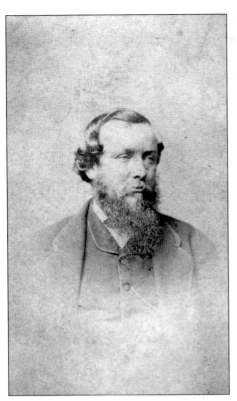

Charles Henry Hutchinson (1835–1914) wrote *The Chronicles of Middletown* in 1906. He also had an insurance agency on North Union Street, specializing in fire insurance. In Middletown, he served on the borough council in 1888 and held the office of chief burgess for three terms. Before arriving in Middletown in the 1880s, he served in the Union army during the Civil War and then was a traveling salesman.

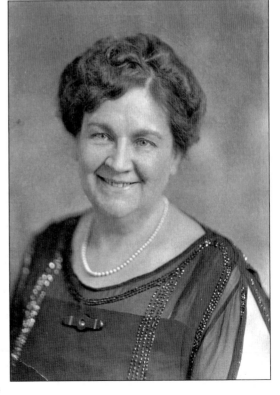

Rachel Fielding Hutchinson Springer (1870–1952), a great-great-granddaughter of town founder George Fisher and the daughter of Anne Shippen Fisher (1844–1930) and Charles Henry Hutchinson, was a well-known lifelong resident of Middletown who was involved in many organizations and activities. At first, she lived at the Fisher family homestead on East Main Street and then later at 104 West Main Street. Her husband, Ira R. Springer (1876–1942), was an insurance man in town. (Courtesy of the family of Edith and Oshea Kagan.)

Eliezer "Louis" Zacks, an immigrant from Lithuania, was one of the 21 charter members in 1906 and the first president of B'Nai Jacob Synagogue. He died in 1919, a victim of the great Spanish flu epidemic that year. After Zacks died, his son Jacob made a promise to his mother that he and his sister would take care of the synagogue their whole lives, and they did. (Courtesy of Larry Kapenstein and B'Nai Jacob Synagogue.)

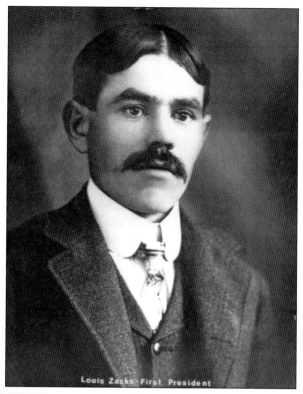

Louis Zacks - First President

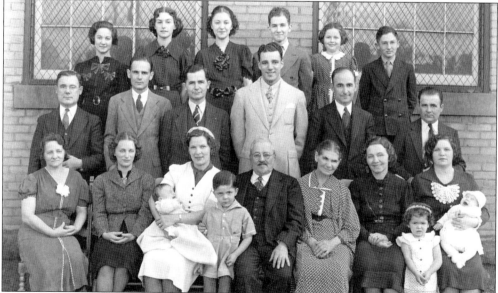

From left to right in this 1937 multigenerational family photograph are (first row) Lena Singer, Jay Singer, Melvin Singer (baby), Mae Singer, Stanley Singer (child), Philip Singer, Mary Singer, Jenny Singer, Judith Singer (child), Sarah Singer, and Flora Singer (baby); (second row) Isaac Singer, Harry Singer, Samuel Singer, Harry Alexander, Jacob Singer, and Abraham Singer; (third row) Gertrude Singer, Charlotte Singer, Esther Alexander, Sidney Singer, Gloria Singer, and Leonard Singer. (Courtesy of Stanley Singer.)

H. J. Wickey was superintendent of the Middletown School District from 1899 to 1934. Before that, he was the district's high school principal from 1896 to 1899. He was also the first chairman of the Middletown chapter of the American Red Cross, organized on April 23, 1917, which was very active during the years of World War I. George Washington Feaser (1901–1980) succeeded him as superintendent. (Courtesy of the Middletown Public Library.)

Feaser was superintendent of the Middletown Area School District from 1934 to 1966. He had a bachelor of arts degree from Elizabethtown College and a master of arts degree from Columbia University. Before becoming superintendent, he was a Middletown teacher and then principal of the high school. He always took pride in being a "distant relative of Daniel Boone." He was also chairman of the Middletown Red Cross throughout its very active years during World War II. (Courtesy of the Middletown Public Library.)

Donald R. "Prof" Miller was a teacher in Middletown from 1928 to 1969. In the 1969 high school yearbook, dedicated to him, is the statement, "His enthusiasm for life has affected not only his economics and government classes, but also the entire student body." During his long teaching career, the very popular Miller was also class adviser many times, adviser to the rifle team, and a tennis coach. (Courtesy of the Middletown Public Library.)

Edward E. Brunner was principal of Middletown Area High School beginning in 1959. He earned a bachelor of arts degree from Elizabethtown College in 1952 and then a master of education degree from Pennsylvania State University. Brunner began his career in 1953 teaching social studies at the high school. Very interested in athletics, he was a head basketball and track coach and assistant for the football team. (Courtesy of the Middletown Public Library.)

Robert G. Reid taught at the old Wood Street, Mansberger, and Grandview Elementary Schools in Middletown beginning in 1959 and then moved on to become a high school social studies teacher in 1970, retiring in 1993. Reid was a borough council member from 1968 to 1978 and then became Pennsylvania's first black elected mayor in 1978, reelected continuously to serve through 1994. The 21st century finds him once again serving as mayor, reelected in 2002 and still in office in 2009. (Courtesy of Robert G. Reid.)

Percy Kupp and his son Karl started Kuppy's Diner on Brown Street in August 1933. In the first 24 hours, they took in $62, which was a lot of money back then. A larger 1938 replacement diner has lasted with some renovations and additions to this day. Percy always said, "If you serve good food at reasonable prices, people will be satisfied," a quotation that has remained on Kuppy's menus all through the years. Percy died in 1950. (Courtesy of Karl Kupp Jr.)

Beane D. Klahr (1900–1992) was a longtime jeweler at 25 South Union Street. His father, Elias H. Klahr, started Klahr's Jewelry Store in 1885. Beane served with the 5th U.S. Cavalry during World War I along the Mexican border, pursuing Pancho Villa and his bandits. After the war, he went back to the store, taking over the business after his dad died in 1934. Beane always said that persistence was the key to success.

Longtime Middletown resident Stella Reese Fritz was born on January 10, 1893, and died on January 4, 2001, just shy of turning 108 years old. During her early years, she lived and worked on the Herr farm in Millersville. In 1919, she married John Fritz (died in 1965), who worked at Olmsted Air Force Base. He was a part of Operation Question Mark, a secret project to develop in-flight refueling of aircraft. They had two daughters, Hilda Hoke and Elizabeth Needleman. (Courtesy of Hilda Hoke.)

Elner Grundon Overdeer (1923–2008) was a lifelong resident of Middletown. A member of the Middletown High School class of 1940, she went on to have a career working for the federal government at Olmsted Air Force Base. After retiring, she had a second career of 15 years as secretary to the borough authority. She was a charter member of the historical society, a regent and secretary of the local DAR, and a member of the Presbyterian church. (Courtesy of Lila Lesher.)

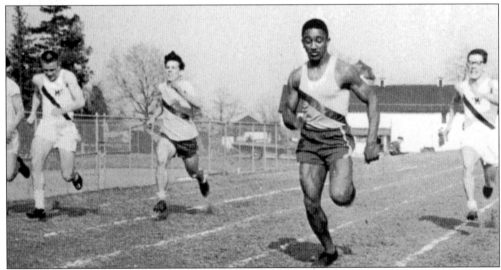

Harvey "Tony" Colston (closest to camera) shows his powerful sprinting stride during a high school track meet. One of Middletown's greatest all-time athletes, he was a star in track, basketball, and football, and he graduated from Middletown Area High School in 1964. He served with the Marine Corps during some of the worst days of the Vietnam War. Returning to Middletown as a corporal, he worked at Harrisburg International Airport until his untimely death in an automobile accident on March 24, 1969, at age 24. (Courtesy of the Middletown Public Library.)

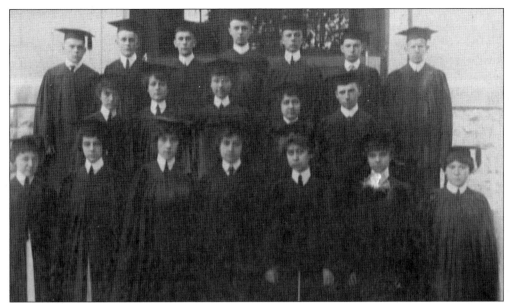

The Middletown High School class of 1915 consisted of 19 graduates. Identified here are Mary B. Ettele, second from the right in the first row, and John A. Keiper, third from the left in the third row. Other members of the class of 1915 were Harry Beard, Eva Blecher, Maxwell Brandt, Sara Deimler, Mary Foltz, Harold Hess, Adam Kaine, Harold Kauffman, Romaine Kennard, John Lingle, Mary Long, Oma Lutz, Ruth McNair, Clarence Phillips, Amy Roop, Elizabeth Seltzer, and Edna Shaeffer.

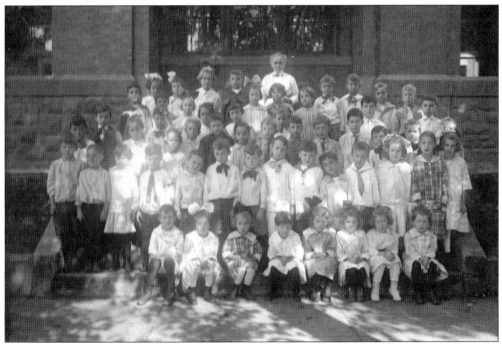

This photograph, taken during the 1917–1918 school year, has students who graduated from high school with the classes of 1928 through 1930. The teacher is a Miss Keener. Carl Arnold is first on the left in the front row.

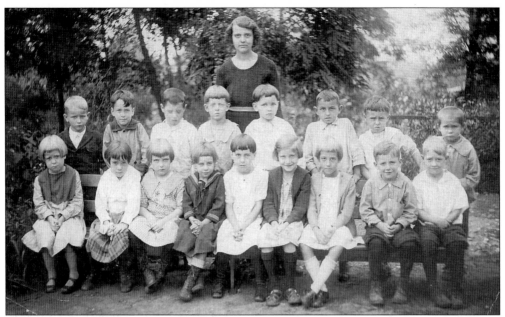

Royalton Primary School first graders pose with their teacher, Theora Peiffer, in the fall of 1923. From left to right are (first row) Margaret Hamman, Edna Hollinger, Bernise Myers, Bessie Bartenschlager, Edith Hickernell, Evelyn Fridinger, Elthera Sides, Lester Zimmerman, and Harry Barnhardt; (second row) Woodrow Keiffer, George Fernback, William Conlin, James Hoover, Paul Crow, Michael Horetsky, Carl Dupes, and Daniel Kreiser. (Courtesy of the family of Edith and Oshea Kagan.)

Identified mostly by last name, members of Middletown High School's class of 1928 are, from left to right, (first row) O. Brandt, Harnly, Sinniger, Grundon, Houser, Rank, Gotshall, Rife, Seiders, Weller, and H. Good; (second row) Kurtz, Troop, Keener, J. Good, Garver, Foreman, Listing, and Coble; (third row) May, Kleinfelter, Landis, Prouser, Stoops, Kern, Hoover, Schaefer, Wise, and Tritch; (fourth row) H. Bauder, J. Bauder, Bachman, Reider, Selcher, W. Brandt, McKinstry, Caley, Ireley, Love, and Myers; (fifth row) Landis, Walmer, Shope, Karadeema, Books, Girton, Swartz, Durborow, Springer, Wealand, and Reeves.

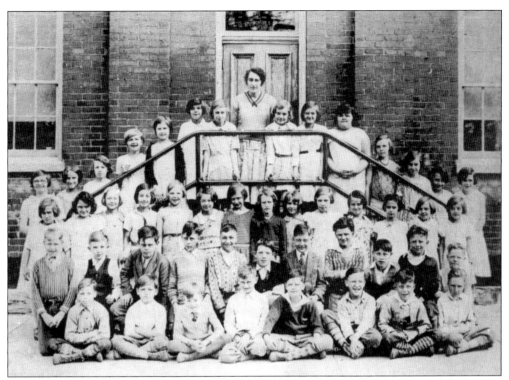

Third- and fourth-grade students pose with their teacher, Bertha Lesher, in front of the Juniata Street School in Royalton in 1931.

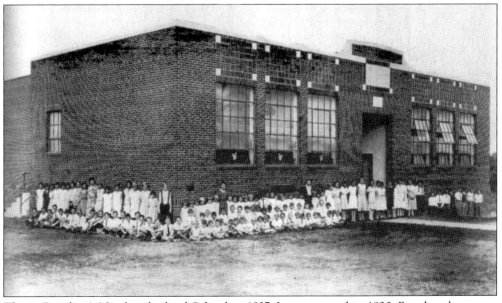

This is Royalton's Northumberland School in 1937. It was erected in 1930. Royalton became a part of the Middletown Area School District in 1959.

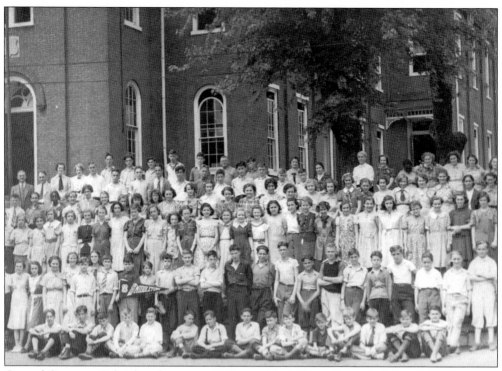

Central Grammar School students pose in front of their Emaus Street building in 1937.

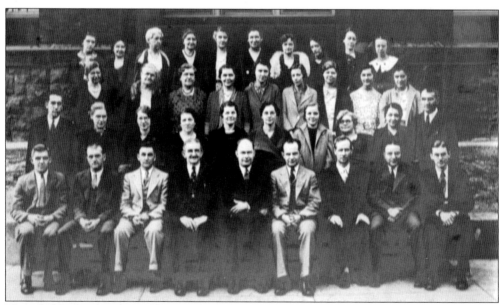

Identified by last name, Middletown School District teachers from the 1934–1935 school year are, from left to right, (first row) Mathias, Miller, Tritch, Martin, Supt. George Washington Feaser, Johnson, Reider, Cassel, and White; (second row) Kugle, Creep, Rife, Rebuck, Mitman, Bachman, Crull, Hill, Wentz, and Hoffman; (third row) Cannon, Yost, Smith, Beck, Rose, Gruber, Brinser, Wealand, and Markley; (fourth row) Longenecker, Weidenheimer, Hoffman, Baer, Peters, Nagle, Carmony, Tait, Force, and Garver.

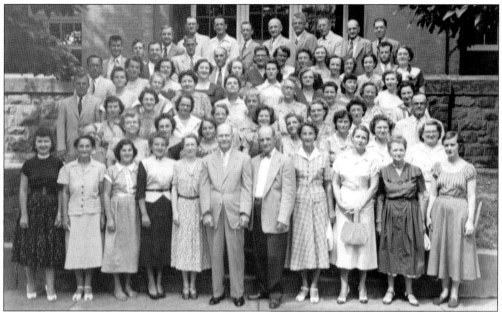

Middletown School District teachers in 1952 are, from left to right, (first row) Christman, Demey, Kaufman, Arnold, Rife, Superintendent Feaser, Johnston, Lehman, Smith, McConnell, and Byrod; (second row) Heisey, Beck, Lubold, Lemon, Force, Morrow, Lesher, Arms, and Geyer; (third row) Roksandic, Kirkman, Baer, Wentz, Neagle, Sohn, Buffington, and Brinser; (fourth row) Butsavage, Schmidt, Graham, Smith, Morganthall, Force, Rambler, Brandt, and Matula; (fifth row) Hummel, Meckley, Wilson, Groupe, Reider, Weidenhammer, Otto, Schenck, and Downing; (sixth row) Bartel, Souser, Kaltriter, Hoffman, Furman, Shank, Snortland, Brendle, Hughes, Wealand, Diberler, Williams, and Prowell; (seventh row) Fair, Cox, Springer, Dubs, Gibble, Shuler, Roksandic, Miller, and Hartman.

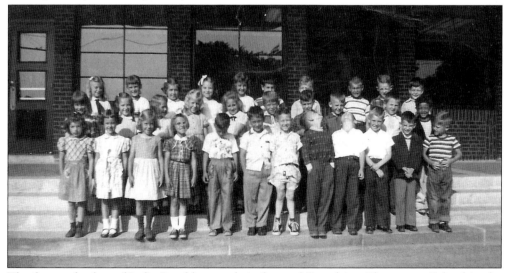

The first-grade class of Lydia Rambler stands in front of Grandview Elementary School in the fall of 1955. Richard Cox was the principal of this school in the north section of town. Renamed the Alice Demey School in later years, it finally closed its doors around 2000. (Courtesy of the family of Edith and Oshea Kagan.)

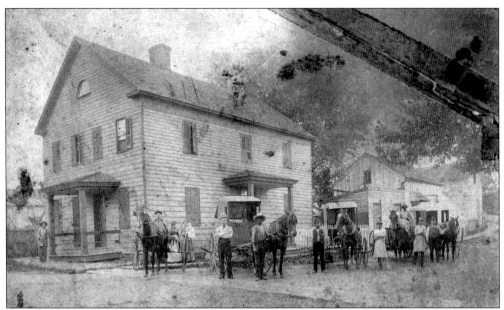

Middletowners in the year 1890 gather at the "Aqueduct corner" with their horses and carriages. From left to right, beginning with the man seated in the first carriage, are John Wagner, Mae Straw, Mrs. William Wagner (holding her daughter Blanche Davis), Dr. Charles Wagner, Ephraim McKoo, A. L. Wagner, Steve Straw (baker), William Wagner (on the coal wagon), Edward Byerly (baker), and Simon Wagner. The popular Souder's Grocery Store behind them was known for its oysters, priced at 10¢ or 15¢ a dozen.

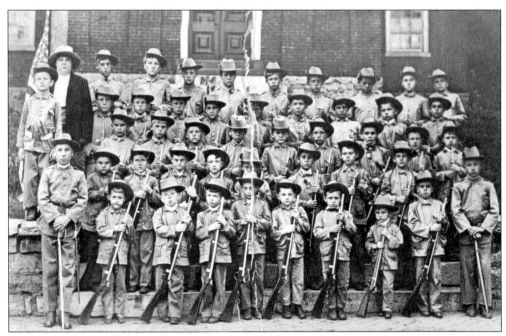

The Boys' Cadets are standing in front of the Emaus Street School. They were possibly part of the Sons of Union Veterans, Col. Ellsworth Camp No. 87, organized on June 28, 1890, by Harry E. Moore, its first commander.

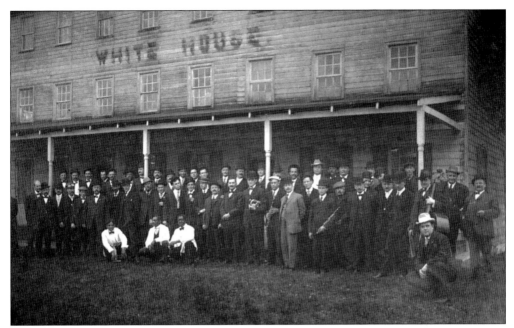

These men are at the White House Hotel. The hotel was located on White House Lane off Route 230 toward the Susquehanna River west of Middletown and at the extreme east end of Highspire, a borough incorporated in 1903. This photograph dates to the 1930s. (Courtesy of Jean Kresge.)

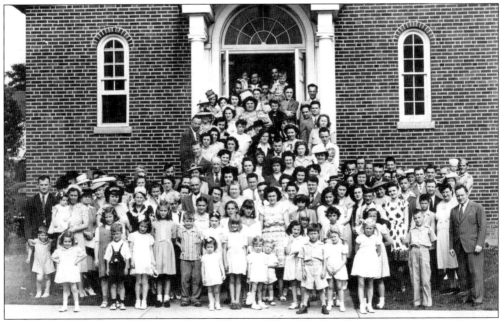

The congregation of the Calvary Orthodox Presbyterian Church stands at the front entrance of its house of worship at the corner of Spruce and Emaus Streets in 1946. The church's first minister, Robert S. Marsden, who served from 1936 to 1939, is at the far right in the first row. Its second minister, Edward L. Kellogg, who served from 1939 to 1946, is the man with the glasses at the top right next to the individual with folded arms.

From left to right, this 1984 photograph shows brothers C. D., Ray, and Nick Farr. In addition to running Swatara Park in the 1950s and 1960s, C. D. was a field auditor for the Pennsylvania Department of Revenue for 25 years; Ray was a penny-scale route salesman and servicer; and Nick, his five children, and wife toured all over the East Coast in their bus in the 1970s and 1980s as the Farr Family Band, playing instruments and singing gospel music in churches. (Courtesy of C. D. Farr.)

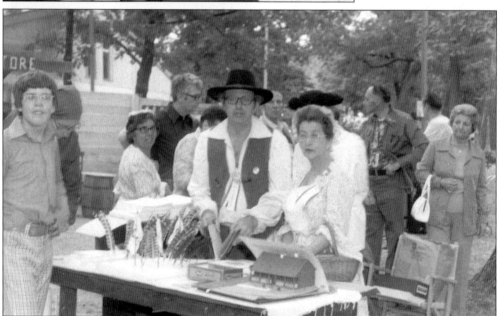

John F. Chubb and Grace I. DeHart tend the Middletown Area Historical Society's stand at the society-sponsored first annual Colonial Arts and Crafts Fair in Hoffer Park in June 1976. Chubb also served as treasurer of the historical society for a number of years; DeHart was on the fair's patrons committee. The annual celebration honors residents who signed the "Middletown Resolves" in June 1774, a document protesting the British parliament's deprivation of rights.

Two

RECREATION AND ENTERTAINMENT

The Middletown Country Club was located on a high bluff across Swatara Creek in Royalton. In the flourishing days of the Middletown Car Works, this club was a grandiose place under the proprietorship of Eddie Collins. Other notable members included George I. King, A. L. Etter, R. P. Raymond, H. A. Clark, and I. E. Shibely. Many parties, dances, and social affairs were held there. With the closing of the car shops in 1930, the club died out.

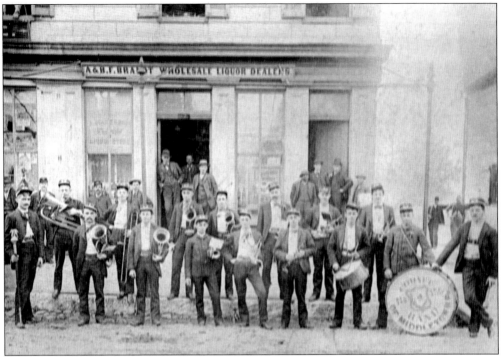

The Cornet Band of Middletown (1855–1863) poses in front of the A. and B. F. Brandt Wholesale Liquor Dealers. The band practiced in Smith's Hall at 239 North Union Street.

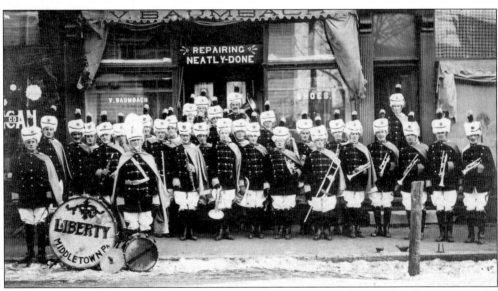

Baumbach's Brass Band was organized in 1858 and then incorporated in 1868 under the name the Original Harmonic Band of Middletown. In 1875, it became the Liberty Band. Its first director was Edward Baumbach Sr., a German immigrant. In 1918, band members purchased their first full uniforms. Well known and often hired to play at out-of-town (and even out-of-state) parades and special events, the band suffered financial and recruiting problems in the 1950s, finally disbanding in 1966.

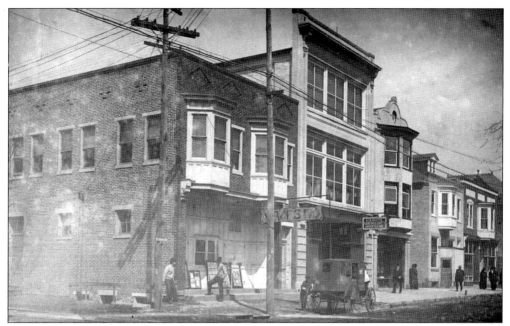

The Majestic Theatre at 33 South Union Street was known for showing Wild West movies. The theater was opened by Edward Condran in 1911 and then sold to Manfred Brothers in 1912. H. S. Roth's furniture, carpets, and undertaking business is next door. (Courtesy of the Press and Journal.)

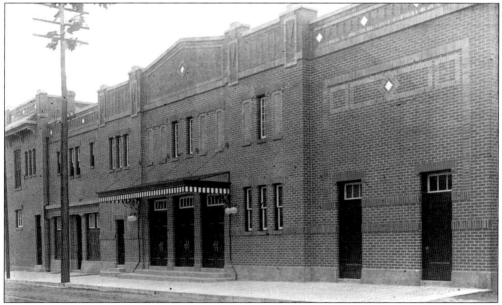

Built on the site of the old Middletown Auditorium and Market House buildings, which were destroyed in the 1910 fire, the Realty Theatre (named after the Middletown Realty Company, which erected the building) opened in October 1911. With its 700 seats, it first showed silent films, using a pianist between reels. In 1931, the year after Elks Lodge No. 1092 bought the building, it was renamed the Elks Theatre. Still showing films in the 21st century, it is one of the country's oldest continuously operating movie houses. (Courtesy of the Press and Journal.)

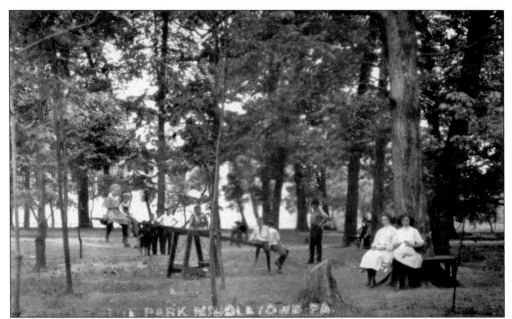

Kids from a time long past enjoy Hoffer Park. At first called the East Middletown Park, it began back on October 24, 1892, when Christian Hoffer (1845–1925) deeded the 4.2-acre land to the borough for $1,000. Through the years, the park, with its large, kitchen-equipped pavilion, became the ideal place for picnics and recreation, band concerts, reunions, and a funded children's activity program during summer vacation months.

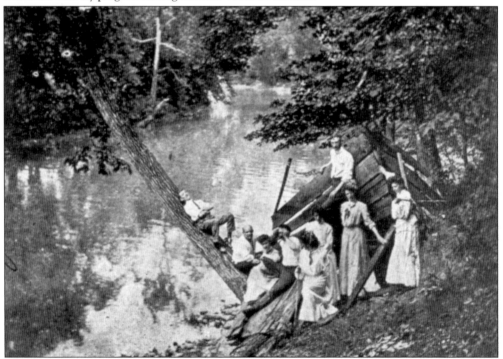

Walking along Swatara Creek was a popular Sunday afternoon recreational activity for young couples in the early 1900s. This site was perhaps near Hoffer Park.

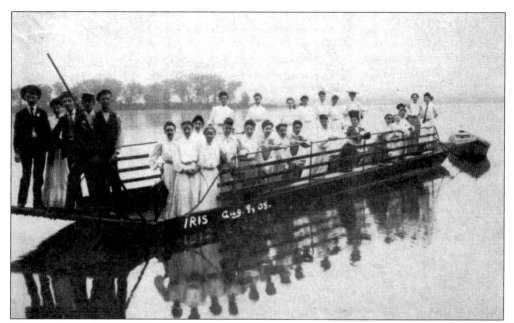

Here on August 9, 1905, 17-year-old George Mansberger is poling a group of Hill Island picnickers on the *Iris* to board the Middletown Ferry Company's larger steamer boat, the *Sylvan Dell*. The ferry service begun by Elijah McCreary in 1893 was sold to George's father, Alvin Mansberger, in 1898. It operated for about 20 years, mainly hauling people and cattle between the east and west sides and up and down the Susquehanna River. (Courtesy of the Middletown Public Library.)

This is a parade at Center Square prior to the street pavings of 1918. Annual fairs were held there for many years. People and dealers reportedly came from miles around to buy the goods and food offered and to enjoy the carnival attractions. Before white settlement, Center Square was reputedly the site of a Native American village called Swahadowrie.

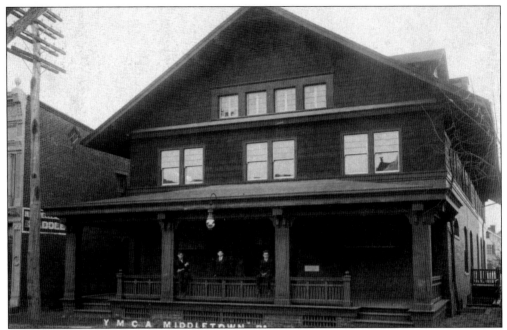

These men are on the porch of the YMCA at 52 East Emaus Street. In the first decade of the 20th century, a men's gospel meeting was held inside every Sunday. A ladies' auxiliary and gymnasium classes were also offered. The building was completely destroyed by the fire of 1910. Much later, this was the location of the Middletown Traffic Service Bureau.

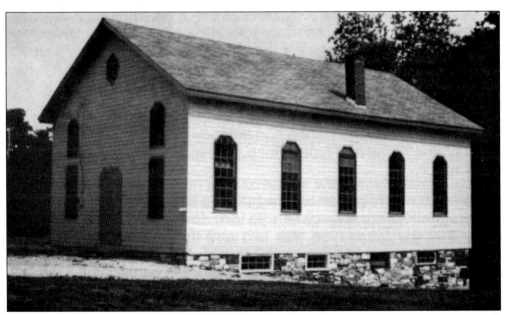

The Liberty Band hall on South Union Street had originally been the Salem Lutheran Church in Oberlin, erected in 1846. In 1916, Middletown's Liberty Band purchased the vacated church for $130 and moved it by horse teams in small sections to its current location on property bought by the band from the Pennsylvania Railroad. After the band's dissolution in 1966, the borough purchased the building, and then the Middletown Area Historical Society bought it in 1981.

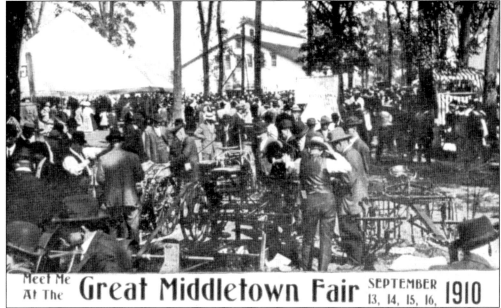

Meet Me At The Great Middletown Fair SEPTEMBER 13, 14, 15, 16, 1910

Believed to have been established in the mid-1800s, the annual September Middletown Fair (held on the huge fairgrounds bordered roughly by Race, Emaus, Pine, and Water Streets) was listed in 1905 as the "largest and best" fair in Dauphin County. In fact, the September 14, 1901, *Middletown Journal* noted a one-day attendance of 10,000 that year. Held up until World War I, the celebration featured footraces, horse races, business and farming displays, and a midway.

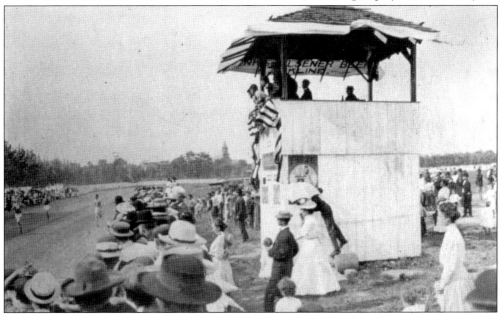

Many people, the grandstand, and a footrace fill this scene at the Middletown Fair. Other exciting events included sulky horse races and Professor Kelly of Reading doing a "balloon ascension and parachute drop to electrify the thousands," both advertised for 1903, and a boxing demonstration by Joe Gans, "champion lightweight pugilist," in 1904. The steeple in the distance is the United Brethren (now Methodist) church on the corner of Water and Spruce Streets.

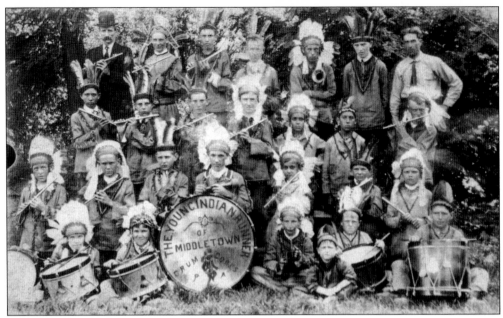

The members of the Young Indian Runner Drum Corps of Middletown pose in 1910. Drum corps were very popular in those days. Another one in Middletown was the Sons of Veterans Drum Corps, led in 1904 by Edward C. Rhen.

This stretch of North Union Street, with the Middletown Cemetery on the left, was known as "Lovers' Lane" during the first half of the 20th century. At times, couples would walk along it out to the Frey farm for watermelon parties. The Emaus Orphan House is visible up on the hill. Lovers' Lane was a very popular spot for taking photographs.

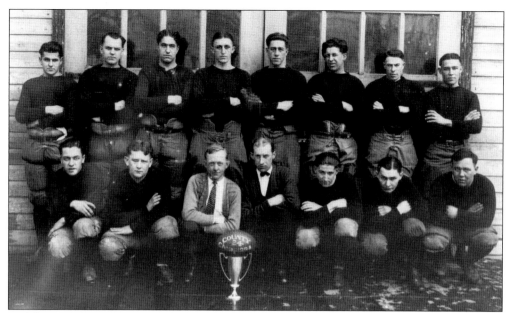

Middletown's 1924 community football team was the undefeated Dauphin County League champion that year. The team played home games on the Lytle farm on Sundays, after first cleaning up the cow patties. In front of Rescue Hose Company No. 3 are, from left to right, (first row) Mel Garman, John Schiefer, Abe Hipple, J. K. Thompson, Glen Yost, Earl Cain, and Karl "Tiny" Schiefer; (second row) Henny Patton, Dutch Wall, Ben Graybill, Raymond Best, Paul Elberti, Ralph Thompson, George Britton, and Charles Beard. (Courtesy of Bonnie Stazewski.)

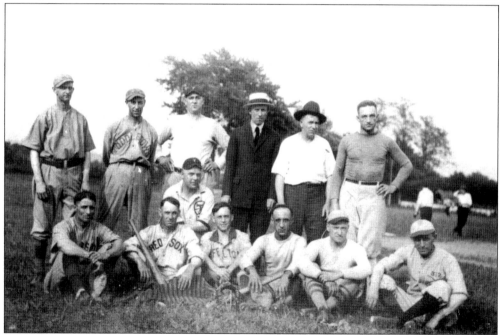

This was Middletown's Red Sox baseball team in the 1920s. Many communities had ball teams, and league competition involving neighboring towns was very popular in the years between the world wars. After World War II, Little League baseball eventually became predominant.

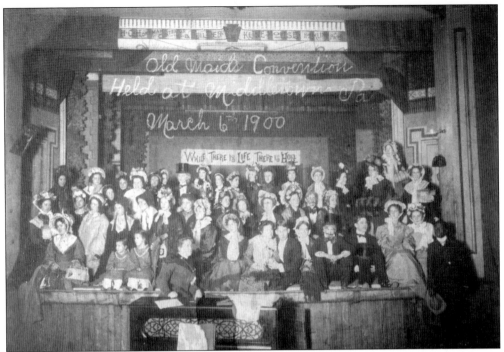

The community play *Old Maids' Convention* was performed on March 6, 1900. The motto was "While there is life, there is hope." It was probably held in the Middletown Auditorium at the corner of Union and Emaus Streets. The comedy was written and directed by Rachel Fielding Hutchinson Springer, standing in the center in front of the stage.

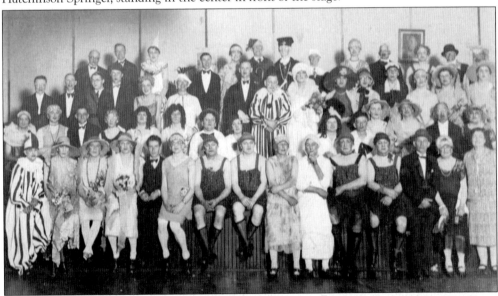

These Middletown residents participated in the 1929 *Home Talent Play*. Interestingly, men played all the parts. The only woman in the photograph is the director, Rachel Fielding Hutchinson Springer, on the far right in the first row. The play was probably performed in Young's Opera House (built before 1852) at 112–114 Ann Street. Musicals, stage shows of all kinds, and graduations were held there.

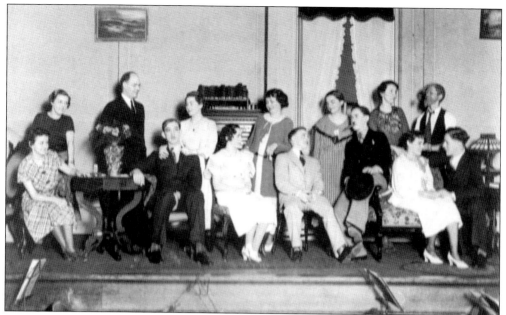

Middletown High School senior class play of 1935 participants are, from left to right, (first row) Dorothy Morrow, Harold Kinsey, Edith Hickernell, Paul Campbell, Donald Conrad, Mary Capka, and Harold Zell; (second row) Bernice Myers, Supt. George Washington Feaser, Genevieve Shrum, Margaret Conrad, Grace Geyer, Permelia Rose (English teacher), and George Keyser. The play was called *Skidding*, a comedy written by Aurania Rouverol in 1928. (Courtesy of the Middletown Public Library.)

A Christmas party was held inside the Liberty Band hall in 1931. Mrs. W. L. Brubaker and Girl Scout Troop No. 54 sponsored it. The "Liberty—1916" banner on the wall recognizes the year the building was moved to its South Union Street location for use by the town's Liberty Band.

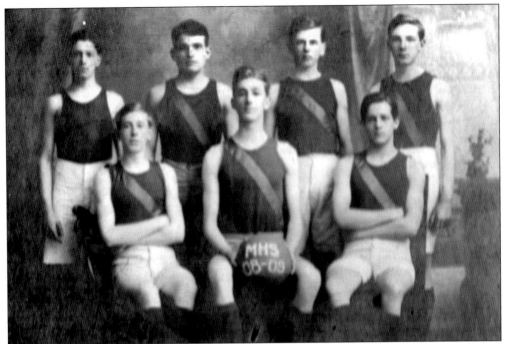

Members of the 1908–1909 Middletown High School basketball team are, from left to right, (first row) Walter Shellenberger, Henry Shellenberger, and J. Frank Park Jr.; (second row) Roy Baumbach, Roy Metzgar, Walter Spurrier, and Harvey Lindemuth.

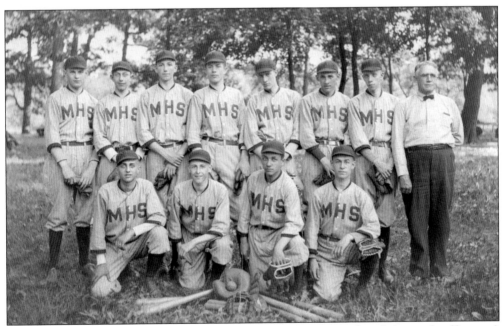

Members of the 1922 Middletown High School baseball team are, from left to right, (first row) Jim Kern, George Sellers, Melvin Garman, and Marlin Brinser; (second row) Don McCord, Edward Rudy, Harvey Weidman, Sol Swartz, Harry Roth, Francis Douglass, Eugene Laverty, and principal Harvey Garver.

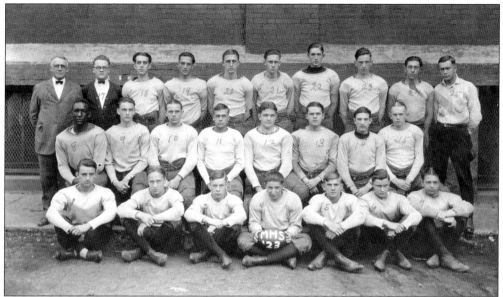

Middletown High School's 1923 football team includes, from left to right, (first row) Russell Leggore, Harold Hartman, Harold Billet, Glen Yost, Charles Klinefelter, Ellsworth Diehl, and Austin Kern; (second row) George Briscoe, Earl Grim, Sidney Steele, Lon Snavely, Gene High, Paul Martin, Dale Ettle, and William Rhodes; (third row) principal Harvey Garver, Lauman Deckard, William Givens, Floyd Schenck, Raymond Best, Wes Hoover, Charles Weidner, Harry Krodel, Ed Rudy, and Phil Dorr.

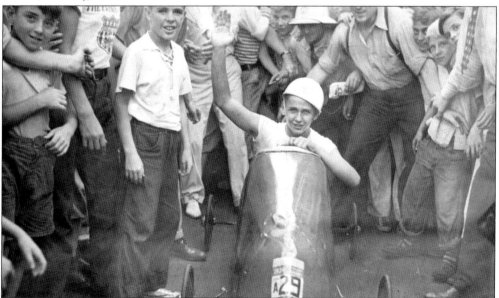

Harry Judy (1924–1996) waves in celebration after winning the Pennsylvania State Soapbox Derby in 1939 at age 15. Judy represented the *Harrisburg Patriot and Evening News* and went on to compete in the national championships in Akron, Ohio, that year. A lifelong resident of Middletown, Judy was a bombardier over Italy during World War II, owned Judy News at the corner of Emaus and Union Streets, and was a two-term mayor of the borough from 1970 to 1978. (Courtesy of Larry Kapenstein.)

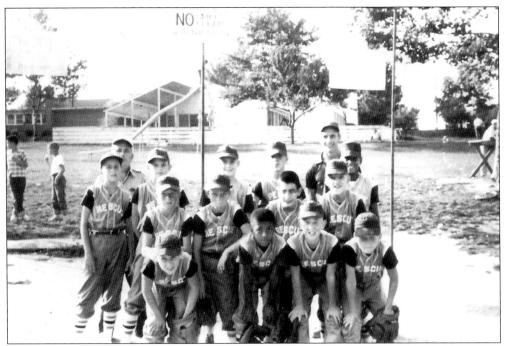

The Rescue Hose Company No. 3 Midgets were Middletown's Little League playoff champions in 1959. Posing at the Pine Ford Acres field are, from left to right, (first row) Dennis Stover, Lewis Whittle, James Kramer, and Frank Cavanaugh; (second row) Thomas Cavanaugh, William Cavanaugh, David Kagan, and Paul Leggore; (third row) Donald Shaneor, Thomas Houser, James Leedy, Lorin Reynolds, and Henry Brown; (fourth row) coaches Colonel Reynolds and John Houser. (Courtesy of the family of Edith and Oshea Kagan.)

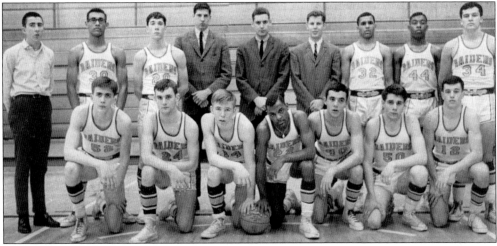

This Middletown Area High School basketball team won the Pennsylvania state championship in 1968. Pictured with their hands on the basketball are David Twardzik (left) and Harold Brown. The other 10 players on the team are Richard Barnoski, John Scudder, Charles Bowen, Charles Etter, Edward Chubb, Barry Ulsh, Edward Tennis, Owen Hannah, Clifton Brown, and Brett Whittle. Twardzik went on to star at Old Dominion University and then played professionally for the Portland Trailblazers. (Courtesy of the Press and Journal.)

Sledders of long ago enjoy the snow at the top of Union Street at Center Square. Note the old-style overhead streetlight. (Courtesy of Grace I. DeHart.)

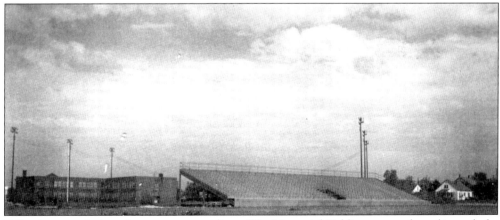

Following completion of a permanent gridiron, War Memorial Field's new grandstand is ready for the opening of the 1948 Middletown High School football season. This impressive structure was built to accommodate approximately 2,000 people. The gridiron and grandstand culminated the alumni association's efforts, begun in 1945 under committee chairman Robert Houser, to erect a modern athletic field "as a memorial to veterans of all wars." George W. Feaser School is behind the grandstand. (Courtesy of the Middletown Public Library.)

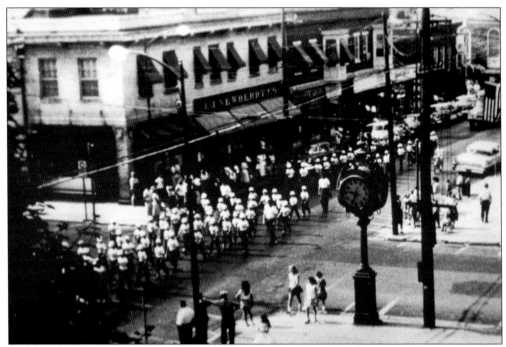

A parade in the 1950s advances north along Union Street at its intersection with Emaus Street. Note the J. J. Newberry Company sign, the town clock in front of the Farmers' Bank, and the old Middletown Post Office and Citizens' Bank and Trust Company building in the distance. (Courtesy of Keith Matinchek.)

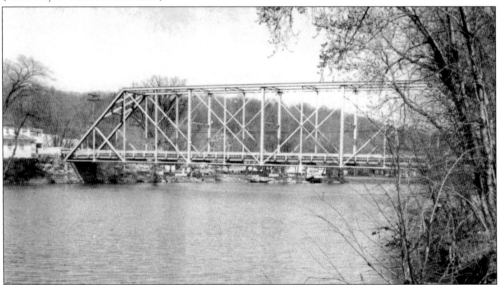

On the west side of the iron bridge (lost to the floodwaters of Hurricane Agnes in June 1972) over Swatara Creek at the north end of Vine Street, Swatara Park provided summer fun for Middletown residents from 1938 to 1971. Started by Donovan Farr as just a nickel-a-person swimming spot with a refreshment stand, it gradually expanded to a regular amusement park, with a Ferris wheel and other rides, a roller-skating rink, a penny arcade, and a bingo hall. The park's speedboat is visible in this pre-1970 photograph. (Courtesy of Grace I. DeHart.)

Three

INSTITUTIONS AND INFRASTRUCTURE

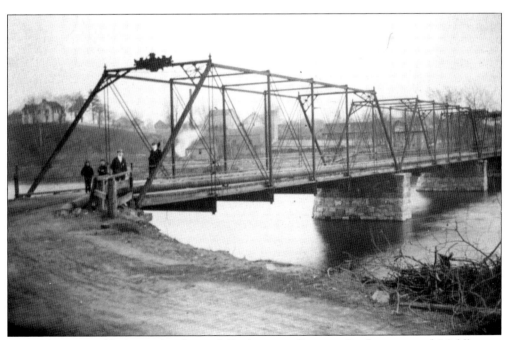

The old iron Grubb Street (or County) Bridge over Swatara Creek connected Middletown to Royalton. In this photograph, taken probably in the first decade of the 20th century, the Middletown Country Club (actually located in Royalton) is visible on the hill to the left, with the Royalton shale brick plant below it to the right.

All dressed up, these two men and three ladies are probably out on a Sunday afternoon walk with a dog to Fisher's wooden bridge in 1900. This crossing of Swatara Creek at Pine Ford was first established in 1736 as part of the very important King's Highway from Philadelphia through Lancaster to Carlisle. At that time, Middletown was still part of Lancaster County, as Dauphin County was not created until 1785.

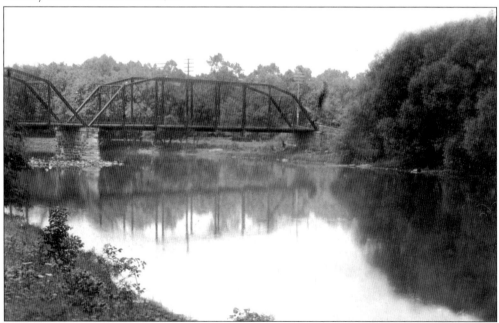

A May 28, 1904, *Middletown Journal* article reported that, to replace the wooden Fisher's Bridge, a "contract for the erection of a steel bridge" had been given to the Eyre Construction Company of Philadelphia for its bid of $12,399. It was to be a two-span structure with a 20-foot driving width. This bridge collapsed in the 1930s when a truck loaded with potatoes passed over it.

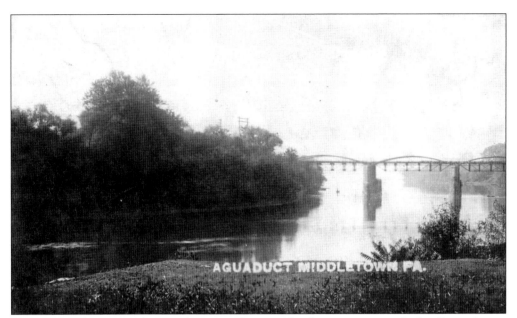

The 300-foot-long Aqueduct Bridge across Swatara Creek was constructed after Pennsylvania state commissioners authorized an extension of the Pennsylvania Canal in 1828 south from Middletown 19 miles along the east side of the Susquehanna River to Columbia. The water channel was 18 feet wide and four feet deep. A steel, arched, horse-and-wagon bridge was attached at one side. A new road bridge replaced it in the 1970s. (Courtesy of Grace I. DeHart.)

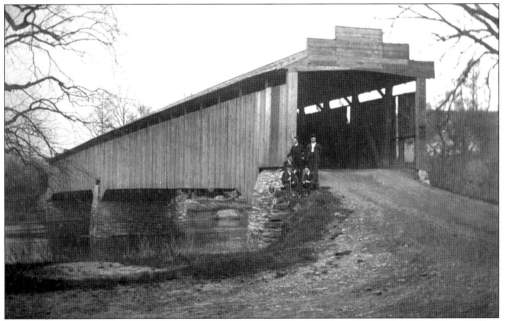

The Clifton covered bridge over Swatara Creek just north of Middletown off the road to Hummelstown was a state-owned, two-span, 234-foot-long Burr arch structure. Theodore Burr patented this type, each of its sides consisting of a great arch sandwiched between two conventional kingpost arrangements, with a level roadway. The bridge was washed away by the floodwaters from Hurricane Agnes in June 1972.

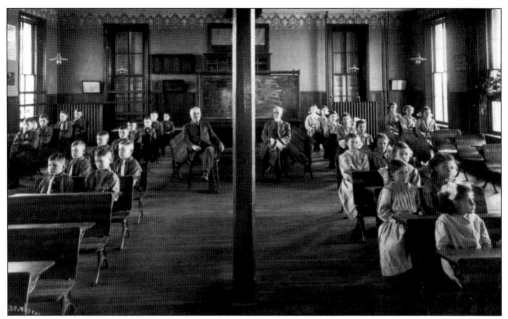

This is the interior of the Pine Street School in 1907. It was located between Main and Water Streets. Constructed in 1835 as the first common school in town, it was remodeled in the 1850s and served as the community's high school until 1869, when those grades were moved to a new building erected on West Emaus Street. (Courtesy of Keith Matinchek.)

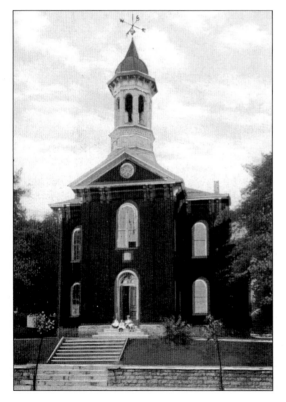

Built in 1868 and 1869, this school on West Emaus Street just west of Catherine Street began as the community's high school. It originally contained just three rooms until an addition was put on in 1888. Shown in this pre-1955 photograph, it became a grammar school after the new high school on Water Street opened its doors in 1910. It was finally razed and replaced with the today's Prince Edwin Lodge No. 486, Free and Accepted Masons.

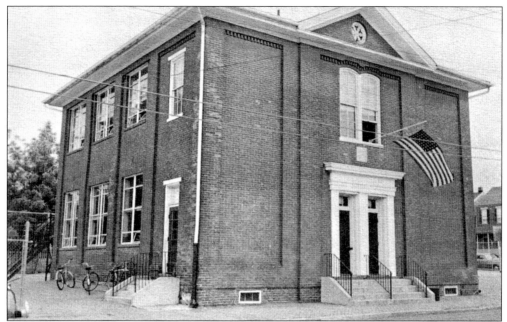

Built in 1866 at a cost of $7,500, this is the Wood Street School on the corner of Wood and Ann Streets in 1955. At the beginning, it had a stove in each classroom and coal oil lamps. It was renovated in 1926 and 1927 and finally razed in 1963 to make room for Mansberger Elementary School, named after George D. Mansberger, a noted citizen of Middletown and a school director for 18 years. (Courtesy of the Middletown Public Library.)

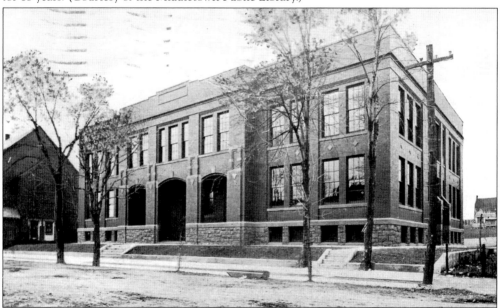

Middletown High School on Water Street, which cost just under $45,000 and opened to its first students in September 1911, closed its doors after the 1962–1963 school year. An auditorium/gymnasium extension on the north side was added in 1936. Although the main building was razed in 1973, the extension has survived into the 21st century and is used for a number of community activities. (Courtesy of Grace I. DeHart.)

During Rev. Robert Atwell's pastorate at Calvary Orthodox Presbyterian Church (1946–1952), a two-story Christian education building was constructed in 1948 at the rear of the parish on Spruce and Emaus Streets at a cost of $17,000. The church granted the Middletown Christian School, which educated students from kindergarten through eighth grade, use of this facility. The school is shown in 1955, when there were 110 children registered and four teachers. (Courtesy of the Middletown Public Library.)

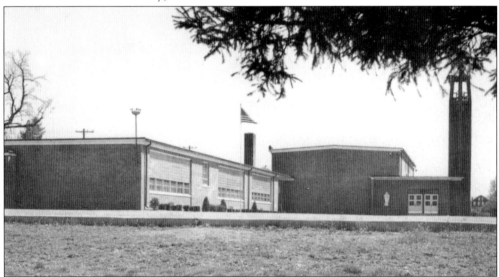

In 1950, approximately 200 Middletown Catholic students were being transported to various Catholic schools outside the borough. This situation was remedied with the opening in September 1951 of St. Mary's Parochial School (connected to the new Catholic church) on the corner of Race and Conewago Streets. Offering kindergarten through eighth grade, by the 1954–1955 school year (when this photograph was taken), the school boasted almost 500 students and an educational staff of six sisters and three lay teachers. (Courtesy of the Middletown Public Library.)

This photograph from about 1910 shows old Sant Peter's Lutheran Kierch, built in 1767 at the northwest corner of Union and High Streets. It was erected on land provided by George Fisher, Middletown's founder. A rental of one grain of wheat a year is paid to a direct descendant of Fisher to this day. Constructed of red sandstone, with a steeple and bell added by 1815, the edifice is the oldest existing Lutheran church structure in Dauphin County. Only special occasion services have been held there since 1879. (Courtesy of Grace I. DeHart.)

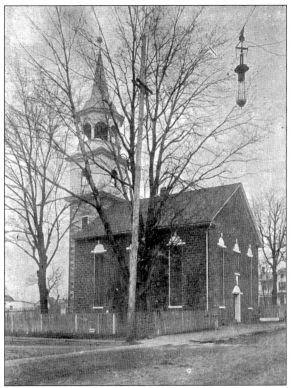

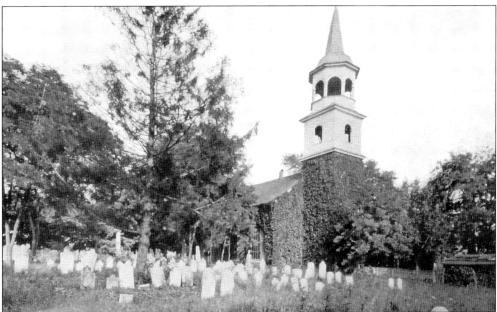

The old Sant Peter's Lutheran Kierch cemetery on the northwest corner of Union and High Streets was named God's Acre. It was acquired in August 1793 from George Gross and his wife for three pounds and a grain of wheat a year (the latter condition dropped in 1807). The first burial was of Johann Conrad Brestel in 1794. Note the ivy growing rampantly up the red sandstone on the northwest side of the church in this old photograph. (Courtesy of Grace I. DeHart.)

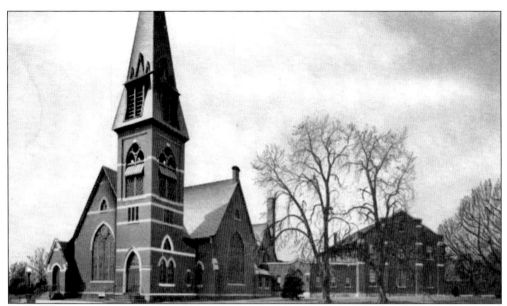

Shown here in 1929, St. Peter's Lutheran Church, located on the west side of North Union Street where it meets Spring Street, became the new house of worship for Lutherans on February 2, 1879. On that day, the congregation marched together from the old Sant Peter's Lutheran Kierch down Union Street about a half mile to its first service in the new Gothic-style edifice. Costing $19,000, the new structure had an auditorium, a chapel, a library, three chandeliers, all stained-glass windows, and a 2,500-pound bell. (Courtesy of Grace I. DeHart.)

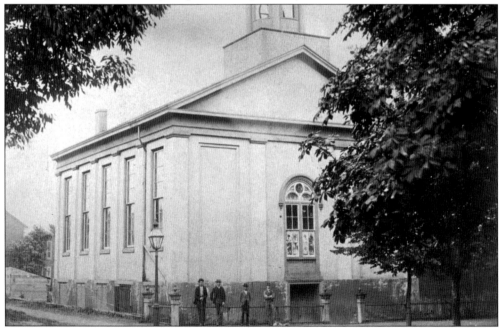

This original Presbyterian church at the corner of Union and Water Streets stood from 1852 to 1890. It was a Greek Revival–style brick edifice. A Gothic Revival red sandstone house of worship replaced it, to which an education building made of matching Hummelstown Quarry stone was added in 1955 and 1956.

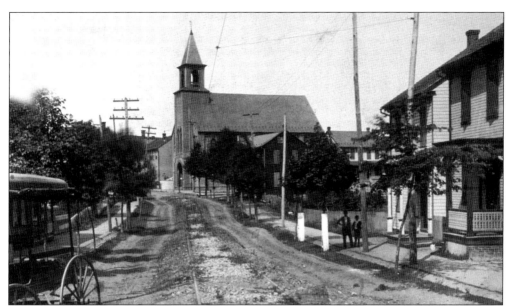

The buggy and streetcar tracks are on East Water Street between Race and Spruce Streets in this photograph from about 1900. The streetcar along here traveled east–west between Race and Catherine Streets. The church at the corner of Water and Spruce Streets was the United Brethren church from its erection in 1892 until 1950, when it merged and became the First Evangelical United Brethren Church. Then in 1968, a further merger resulted in its designation as the Evangelical United Methodist Church.

Newly erected and dedicated on April 27, 1884, the Wesley United Methodist Church (shown in 1955) at the corner of Ann and Catherine Streets replaced a smaller edifice that had been nearby on Ann Street since 1854, which had replaced an even smaller one built on North Union Street between 1814 and 1816. During the 1936 flood, the church provided a home for 87 people until the water receded. In the late 1970s, due to deterioration, the sanctuary was razed and replaced by a new house of worship.

Shown in 1955, the First Church of God at Spring and Water Streets was built in 1894 to replace a house of worship that had been on the east side of Union Street about halfway between Water Street and Center Square. It served the congregation until March 1983 when the ceiling collapsed. The congregation then worshipped in the Presbyterian church nearby and later in the gymnasium of the old high school next door until its new sanctuary on West High Street was erected in 1985. (Courtesy of the Middletown Public Library.)

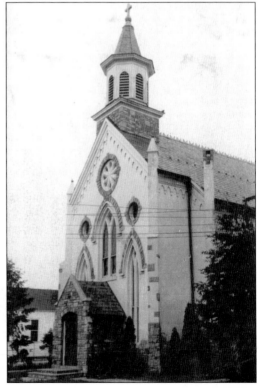

Land on Ann Street for a Catholic church was purchased from Dr. Stephen Wilson in 1857 for $150. Shown in 1955, St. Mary of the Seven Dolors Catholic Church was erected, with services beginning in 1859. A mission church until 1891, it then became an independent parish. The congregation grew greatly after 1940, numbering 2,800 by 1955, and an additional place of worship and an attached school were built on Race and Conewago Streets in 1950 and 1951. (Courtesy of the Middletown Public Library.)

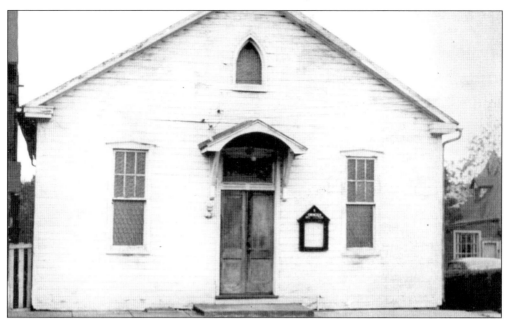

This Ebenezer African Methodist Episcopal Church building was erected on Market Street in 1884 under the direction of Rev. Santee Birch and a gathering of former slaves. It served its congregation until it was totally destroyed by a fire on April 17, 1969. Determined to rebuild, the congregation and many Middletown friends joined together, and on December 7, 1969, ground was broken for a new church close by the site of the original. It was dedicated in 1972. (Courtesy of the Middletown Public Library.)

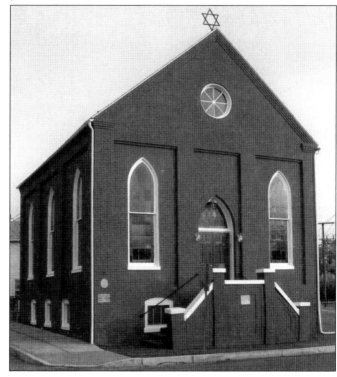

B'Nai Jacob Synagogue, completed in 1906, was erected from plans drawn up by Middletown businessman Samuel Krauss. The synagogue, at 30 by 40 feet and capped with a Star of David ornament, has a front-gabled end facade distinguished by brick recessed panels within which are placed pointed-arch, leaded, stained-glass windows. Listed on the National Register of Historic Places, the synagogue is the oldest one in Dauphin County in continuous use. (Courtesy of Larry Kapenstein and B'Nai Jacob Synagogue.)

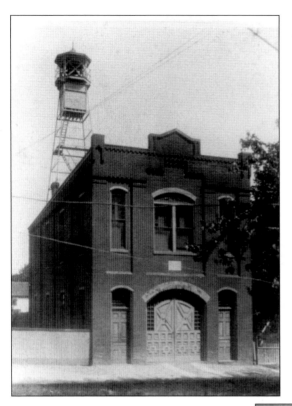

Liberty Steam Fire Engine Company No. 1's brick building on Catherine Street above Emaus Street was erected in 1891, and a bell tower was added in 1911. The company was organized on November 7, 1874, with 35 life members at the time. The fire company used the building until 1974. On January 8, 1978, after renovations, it was dedicated as Liberty House, home of the Middletown Public Library and the Middletown Area Historical Society.

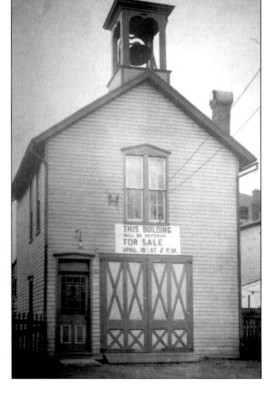

This is the original 51 East Water Street Union Hose Company No. 1 frame building with bell tower being offered for sale in 1903. At first called the North Ward Hose Company when it was organized in 1886, the company reorganized in 1889 and took the name of the borough's first fire company, the Union, which was organized in the late 1820s. A two-story brick structure replaced the frame one on the site in 1905.

Rescue Hose Company No. 3, seen in this early-1900s photograph, was organized in 1888, becoming the third fire company in town. Its building on South Union Street was erected within a year. Before the end of 1889, a bell tower was added. In 1903, a bathroom was installed, and in 1904, steam heat was put in and the station equipped with a kitchen. In 1902, an 11-piece drum corps was formed. An ambulance was purchased in 1924.

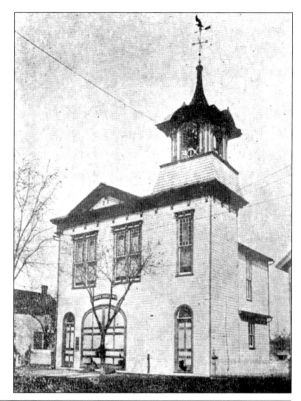

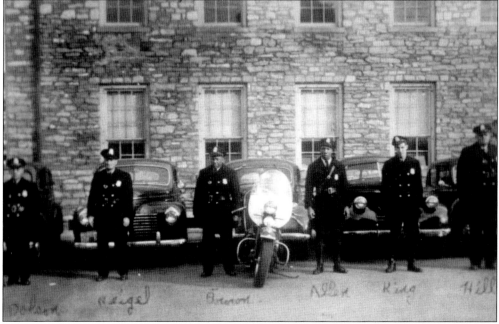

Middletown policemen stand in front of the borough hall at the corner of Emaus and Catherine Streets in the 1940s during World War II. From left to right are Ben Dolson, ? Reigel, Cortez (Tiz) Brown, Robert Allen, Robert King, and acting chief Henry (Hen) Hill. (Courtesy of Keith Matinchek.)

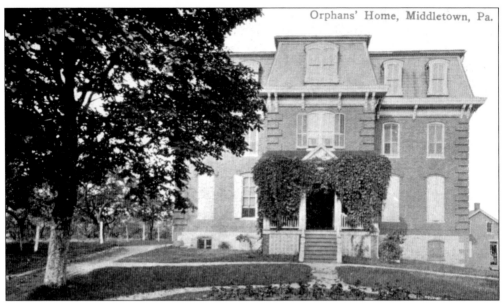

Built on 30 acres purchased from James Young for $4,500, Emaus Orphan House was erected in 1873. Provided for in George Eberhardt Frey's will, the North Union Street orphanage was a three-story L-shaped building with 28 rooms. It eventually had an orchard and gardens (with the fruits and vegetables sold by cart in town by the boys), a springhouse, and a barn. It housed and educated orphaned children up to the age of 16, operating until 1964. The building was finally razed in 1974.

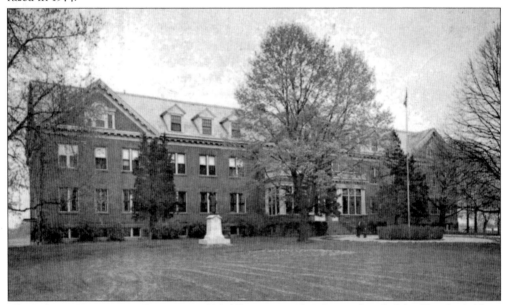

The Jednota Home opened just west of Middletown in 1914. It was founded for Slovak children who were totally or partially orphaned, often by their parents' dangerous occupations in mines, mills, and refineries. Between about 1880 and World War II, approximately 800,000 Slovaks immigrated to the United States, with perhaps half ending up in Pennsylvania. This Catholic orphanage cared for an estimated 4,000 or more children before its closure in 1969. (Courtesy of the Middletown Public Library.)

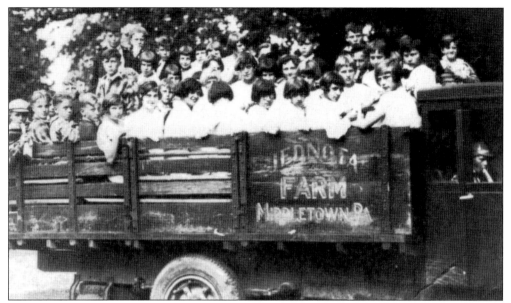

Jednota orphanage children ride in a farm vehicle in the 1930s. Boys and girls up to the age of 16 were cared for, with the boys learning farming and the girls learning housekeeping and sewing. All received instruction in regular school courses, and each student learned to play an instrument, participating in the boys' band and a mixed band. Varied recreations included baseball and basketball. (Courtesy of the Middletown Public Library.)

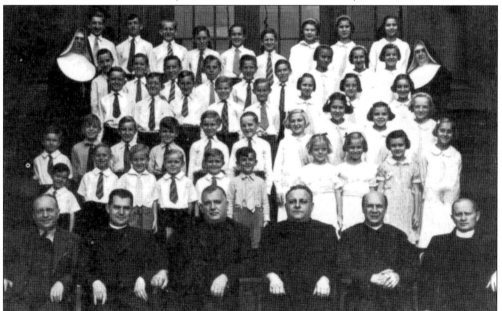

This 1937 photograph shows the Jednota orphans, two sisters (in charge of training the children), and, from left to right seated in the first row, Joseph Husek (editor of the *Jednota Weekly*), Rev. Ferdinand Mondok, Msgr. Dr. Joseph Tiso, Rev. Thomas Caban, Msgr. Karol Koper, and Rev. Michael Kosko (Jednota chaplain). The four men in the middle were visitors from the St. Adelbert Society of Slovakia. The communists later put Tiso to death. (Courtesy of the Middletown Public Library.)

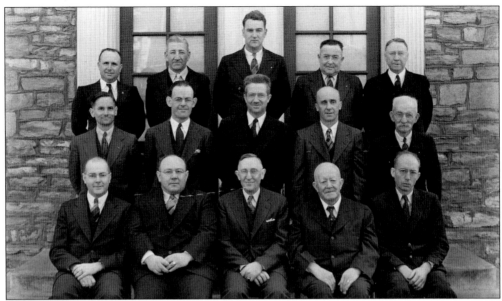

The 1941 borough council members are, from left to right, (first row) W. L. Berkstresser, finance; Karl Schiefer, highways; W. L. Schaefer, president; H. E. Force, fire and police; and W. K. Swartz, light; (second row) B. D. Klahr, John R. Brinser, parks; H. V. McNair, burgess; Charles Baumbach, buildings; and R. S. Gutshall, bills and ordinance; (third row) R. R. Waltermyer, engineer; Erney Spangler, light superintendent; H. K. Houser, chief of police; C. B. Force, clerk; and M. R. Metzer, solicitor. (Courtesy of Jeffrey Stonehill and Middletown Borough.)

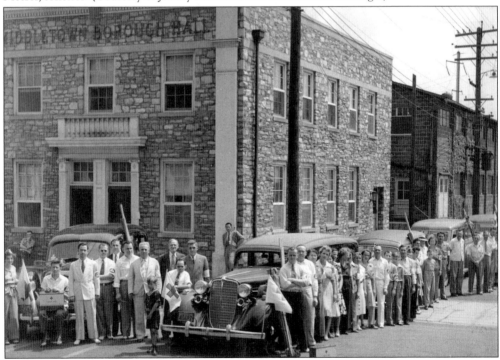

Civil defense volunteers pose in front of the Middletown Borough Hall in 1942 during World War II. Notice the armbands with the Medical Corps insignia.

Four

BUSINESS AND INDUSTRY

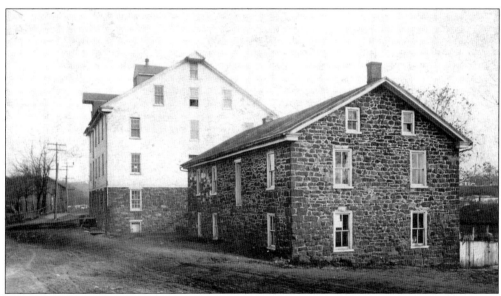

Frey's Mill was built sometime after the 1750s on the west bank of Swatara Creek along present-day Mill Street by Dr. John Fisher, son of George Fisher, the founder of Middletown. George Eberhardt Frey and John Hollingsworth purchased the gristmill from Fisher in 1784. Frey operated it mostly on his own from about 1787 until his death in 1806. During this time, business flourished greatly, with flour shipped to Philadelphia, Baltimore, Virginia, the Carolinas, and even to Europe. During the first half of the 20th century, it was Solomon Brinser's and then his sons' corn meal mill. It stands today as an apartment complex. (Courtesy of the Press and Journal.)

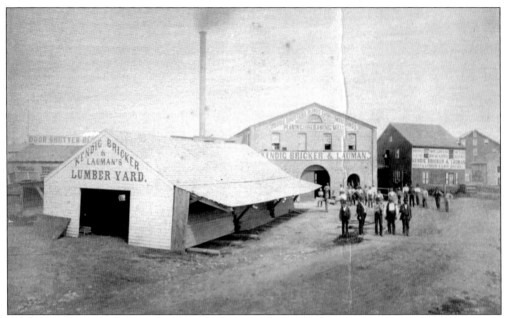

The Walter Kendig, John Bricker, and William Lauman lumberyard and mill flourished from 1874 until 1910. It was run by all three men until 1883, by just Kendig and Lauman through 1904, and by the Lauman estate until 1910. Located on the north side of Mill Street, the mill was first established in 1852 by Chris and Daniel Kendig and run by them until they sold it in 1874. Running day and night, the lumber mill was considered one of the finest in the state.

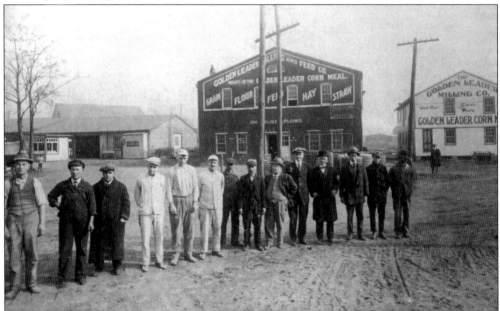

In 1912, the Golden Leader Milling and Feed Company purchased the former Kendig and Lauman planing mill building at 125 Mill Street. By 1914, it was producing flour and feed under the name of Brinser Milling and Feed Company. A 1931 advertisement offered, "Golden Leader Corn Meal, building supplies, and feed." This was the year of the company's last listing in the Industrial Directory of Pennsylvania.

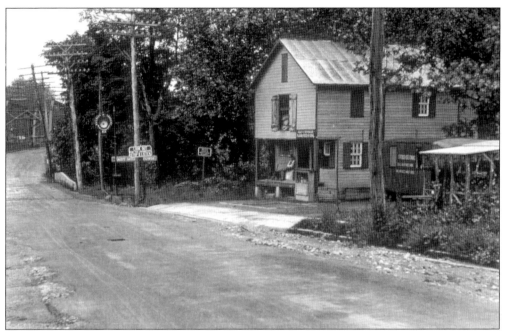

Espenshade's Feed Mill was at the east end of town on the south side of Main Street right before Fisher's Bridge. A 1931 advertisement promoted, "Allen Espenshade, dealer in flour, feed, coal, wood, hay, straw, etc., bell phone 394." The Union Canal and the Reading Railroad went across Main Street just east of the mill. Note the Look Out for the Locomotive, Stop and Listen railroad crossing, and East Middletown signs.

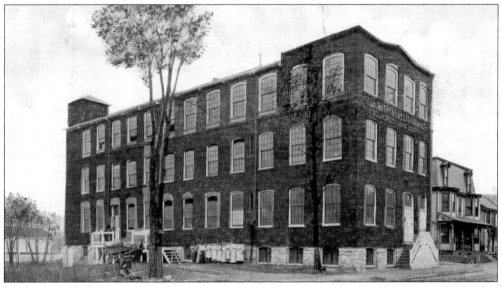

The Henry Romberger Manufacturing Company began operations in 1898 in this newly constructed 41-foot-wide-by-120-foot-long stone and brick building at 136 North Pine Street. This knitting and hosiery mill had 30-horsepower engines, a large hydraulic press, 22 knitting machines, 11 wrappers, and 50 loopers when it opened. The plant was destroyed by fire on January 2, 1917, but Romberger reopened in what is now the community building, with the plant operating until the mid-1930s. (Courtesy of Grace I. DeHart.)

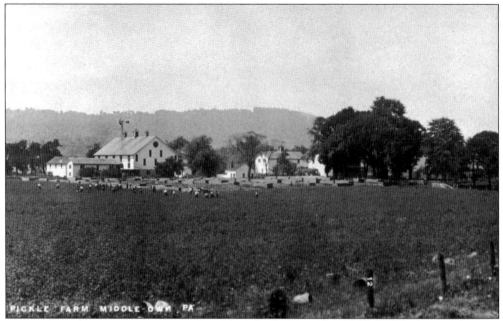

Back in 1890, the future site of Olmsted Air Force Base's airfield and later the Harrisburg International Airport was the Hubley pickle farm. It grew cucumbers for the H. J. Heinz Company.

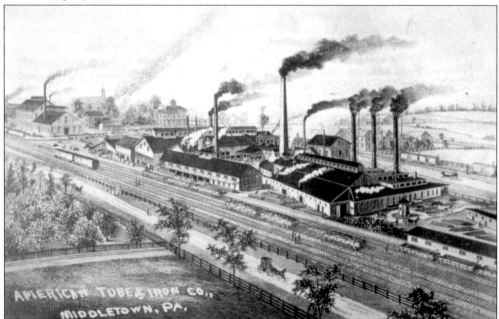

Originally known as the Pipe Mill when it was started in 1872 by Cornelius Walborn, the factory was located on the south side of West Main Street and at the west end of Ann Street. Making pipes, boilers, and tubes, the business was purchased in 1880 by George Matheson and his two sons and renamed the American Tube and Iron Company. In 1895, the plant was sold to the National Tube Company. Finally in February 1909, the mill closed without warning, ending employment for over 1,000 men.

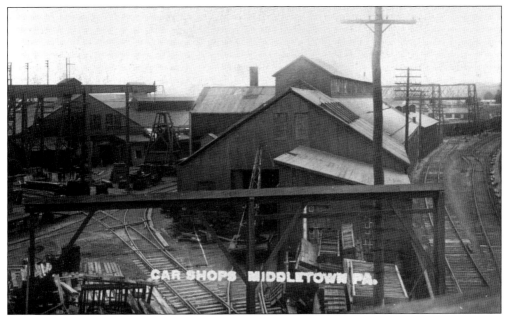

These are the Middletown Car Works buildings along the south side of West Main Street at the overhead bridge area in 1905. First incorporated in 1869, this railroad car–manufacturing plant became a subsidiary of the Standard Steel Car Company in 1912. The company began designing and manufacturing the first all-steel boxcars, sending them to a worldwide market. The Middletown plant ended operations in 1930.

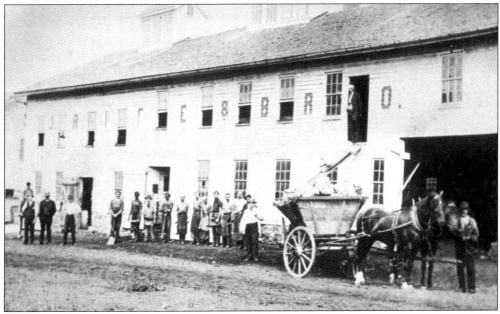

The J. Rife and Brother Tannery (also known as the Keystone Tannery) on the north side of West Water Street took up most of the block bordered by Catherine Street, Spring Street, Water Street, and Mattis Avenue. Brothers John W. and Jacob F. Rife operated it beginning in 1871. By 1879, they were shipping fine leather goods to all parts of the United States. Despite some devastating fires, the business continued very successfully into the 20th century.

In 1925, the Michael Bachman Shoe Company took over the old Bayuk Cigar Company building at the corner of Wood and Wilson Streets and manufactured women's shoes. It is pictured on the left, with the Kreider/Rough Wear building on the right. To improve profits, it added a line of infants' shoes, most famously the Busy Toes. By 1931, about half a million shoes had been distributed to almost every state. In 1947, the Bachman family sold the business.

The A. S. Kreider shoe factory was erected at the northeast corner of Wilson and Wood Streets in 1908 and 1909. By 1912, about 1,600 pairs of adults' and children's shoes were being produced daily by the approximately 300 workers, with men averaging $12 a week and women making $7.50. The business closed its Middletown operation around 1925, and the Rough Wear Clothing Company purchased the building in 1928. (Courtesy of the Press and Journal.)

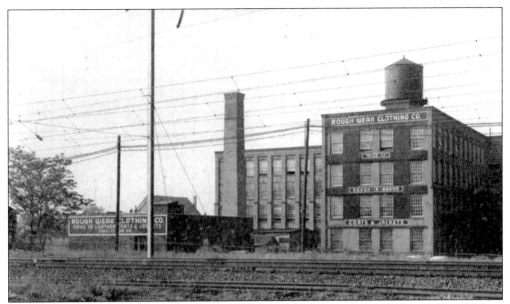

The Rough Wear Clothing Company came from New Jersey to Middletown in 1928. Workers manufactured sheep-lined and leather clothing, gaining fame for the company in 1934 when its coats were used by Adm. Richard Byrd and his explorers on their Antarctic expedition. Additional fame came during World War II when a half million of its leather jackets and flying suits were used by America's armed forces. The business closed in 1981. (Courtesy of the Press and Journal.)

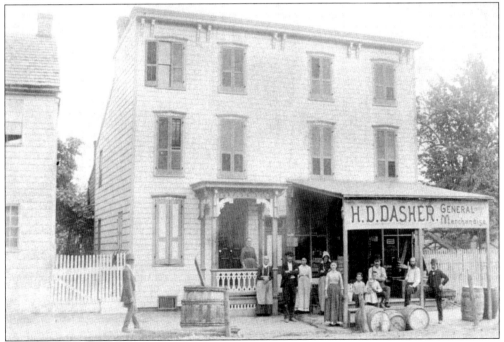

This 1875 photograph shows Hiram D. Dasher's grocery and general merchandise store on East Main Street. He was retired by 1908 but died the next year, with his wife, Deliah, surviving him.

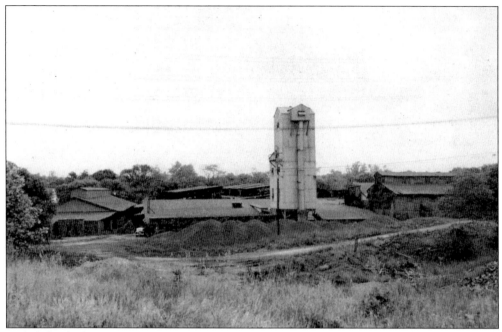

A shale brick plant was erected on the east side of Swatara Creek across from Mill Street around 1900. Known in its earliest years as the Middletown Shale Brick Works, among a couple other names, in 1939, it became the Glen-Gery Shale Brick Corporation. By 1955, production by the plant's 50 men reached 300,000 bricks a week. This brick was considered to be second to none in the United States. The plant closed in the 1960s.

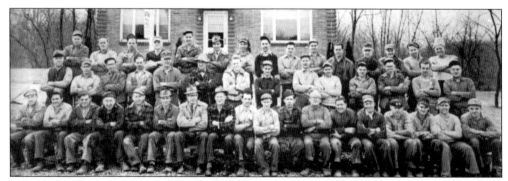

Identified by last names, members of the 1952 Glen-Gery Shale Brick Corporation crew are, from left to right, (first row) unidentified, unidentified, Meco, Stiver, D. Kinsey, Flack, Long, Kunkel, Leggore, Edie, unidentified, Lockard, Smith, L. Givler, E. Givler, Quaca, Keiffer, and Shank; (second row) Derr, May, Crum, Famis, unidentified, Kimberline, Kitner, S. Flowers, L. Kinsey, Dimeler, unidentified, Schmink, W. Flowers, and Keyser; (third row) unidentified, Kooser, unidentified, Foltz, Long, Boyer, H. Keene, E. Keene, Brochious, Lines, Hemperly, Arndt, Kunkel, Seibert, and Chestnut.

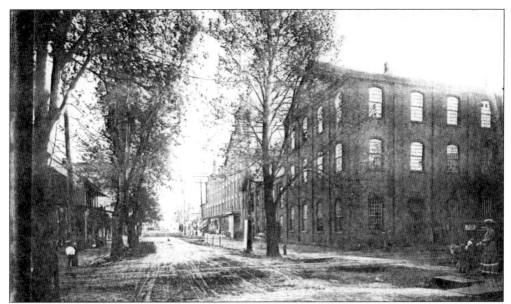

This photograph from about 1900 is of the Seymour Raymond and Joseph Campbell Manufacturing Company on South Union Street. Engaged only in the manufacture of stoves, the business was begun by Raymond around 1850, producing coal stoves and woodstoves, and Campbell joined him in 1865 when steam boilers were added. In 1912, the business was renamed the Wincroft Stove Works. Note the Pennsylvania Railroad tracks in the distance down Union Street, before the subway underpass was constructed.

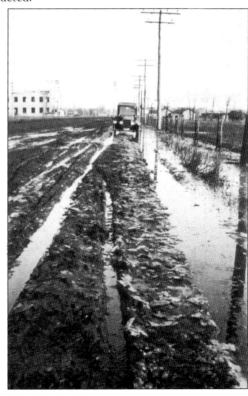

To the north along Route 441 below Royalton, Vogt's-Farm-Meat-Products Company Meat Packing plant (named after president Guy Vogt) dominates the scene in 1919. Note the condition of the road in those prepavement days.

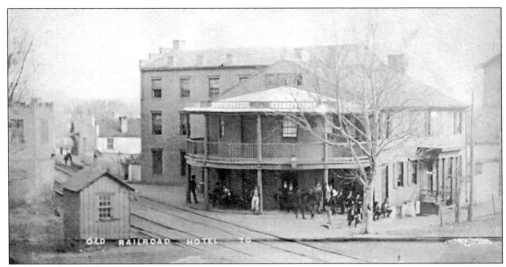

This is the old Railroad Hotel, also known as the Raymond and Kendig Hotel. It was located on South Union Street just off the double tracks of the Pennsylvania Railroad on the southeast side right before the subway underpass that was built in 1902, sometime after this photograph was taken. It appears that it was quite a gathering place for the menfolk. Gone now, it was in existence since around 1850.

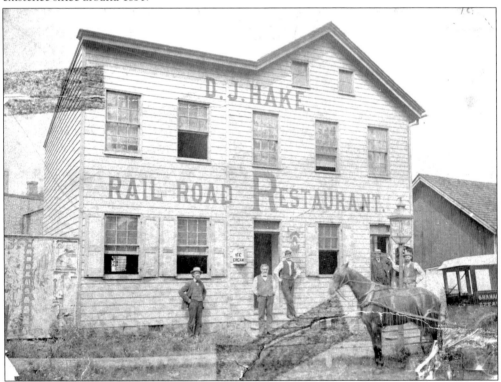

Five men and the horse-drawn Graham Bread truck stand in front of the D. J. Hake Rail Road Restaurant at 17 East Mill Street sometime before 1900. Hake was retired by 1908, and G. A. Schwan is listed as the proprietor in that year; then an A. Kripp owned it by 1913. The establishment was later known as the Millhouse Restaurant.

The Washington Inn on the southeast corner of Main and Union Streets was built in the late 1700s. A Mrs. Wentz was the landlady in 1807 when a traveler named Mr. Cummings stayed overnight, writing of his experience, "I found myself in Mrs. Wentz's excellent inn, the sign of George Washington. I got a good supper and an excellent bed, rose early and breakfasted with my landlady, an agreeable, well-bred woman." The building was razed late in the 1900s.

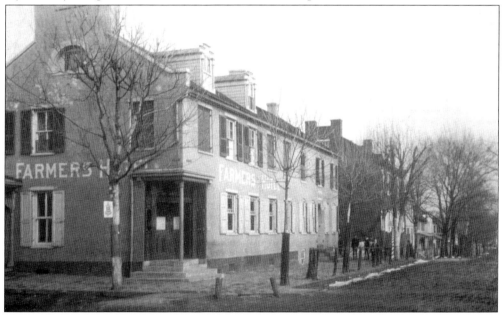

This is the Farmers Hotel, located at 103 East Main Street on the corner of Pine Street, looking to the east. A favorite of teamsters, through the years it was also known as the Franklin Hotel and the Blackhorse Tavern earlier when David Kiseker was the owner. Today it is the Lamppost Inn. Martin Snyder was the proprietor in 1913. On the second Tuesday of April 1828, the first local election was held here after Middletown's incorporation as a borough that February.

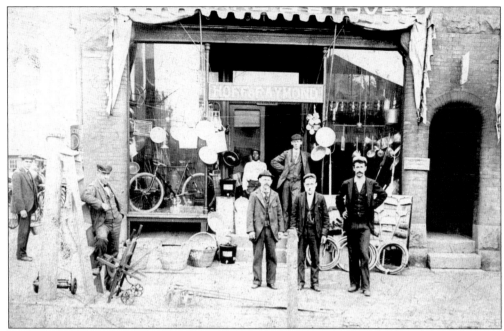

Well-dressed men stand outside the Charles Hoff and Robert Raymond Hardware and Stoves store display window at 7 South Union Street. The Hoff and Raymond sign evidences that this photograph was taken before May 21, 1903, because on that date, the partnership was dissolved "by mutual consent," with the business known just as Raymond's Hardware afterward.

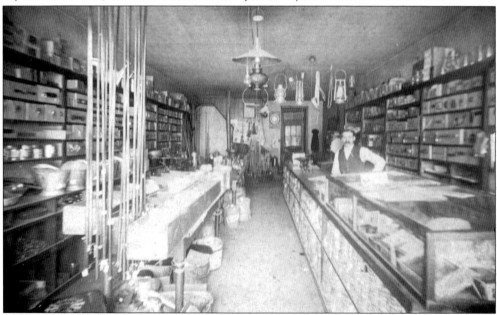

Robert P. Raymond stands inside his hardware store at 7 South Union Street. A 1926 advertisement called his establishment, "the Red Front Store." His store flourished in the second and third decades of the 20th century. In addition to the hardware available there, Raymond sold athletic goods, fishing supplies, and wedding and birthday presents. In fact, he was known for selling "most anything." (Courtesy of the Press and Journal.)

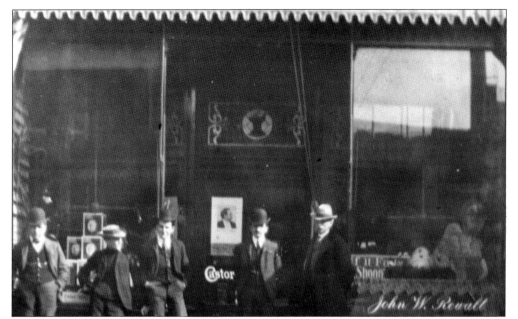

John W. Rewalt ran his drugstore at 6 South Union Street from about 1860 until his death in 1909. One of his advertisements around 1900 offered "Keller's Catarrh Remedy—the great blood purifier of the world." He also sold "Dr. Howard's specific for the cure of constipation, dyspepsia, sick headache, dizziness, liver trouble or a general played out condition." Note the stained-glass window above his store's door.

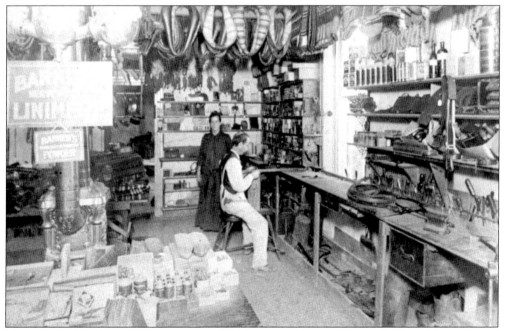

Mr. and Mrs. Charles A. Seltzer pose inside his harness shop in 1905 at 239 North Union Street. Their house was next door at 237 North Union Street. A July 1903 *Middletown Journal* entry reported, "Seltzer, the well known saddler, is making some improvements to his property—a new front, large porch and interior improvements." He was still in business in 1920.

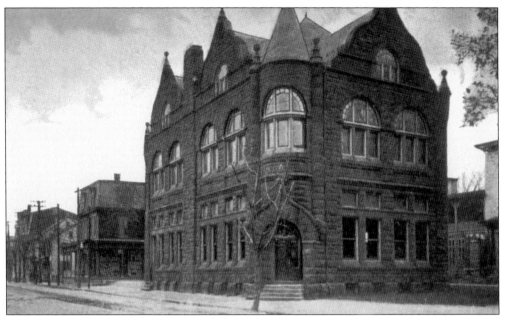

This is certainly a pre-1923 photograph of the Farmers' Bank at the corner of Emaus and Union Streets, because in that year, the large clock was placed in front of it. Built in the 1890s, constructed of brownstone from the nearby Hummelstown Quarry, and adorned with towers and a Moorish entrance, the bank survived for about 100 years, undergoing several name changes. Today it is the Brownstone Cafe.

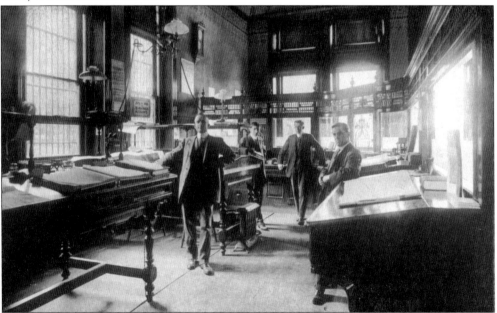

Inside the Farmers' Bank in 1904 are, from left to right, employees Simon Cameron Young, John Reager, Benjamin Longenecker, and an unidentified man. Young later became president of the bank. He also owned the Rosedale Stock and Dairy Farm just west of Middletown, which supplied milk for one of the town's principal dairy routes. Note the "3½% paid on savings accounts" sign on the wall. (Courtesy of Keith Matinchek.)

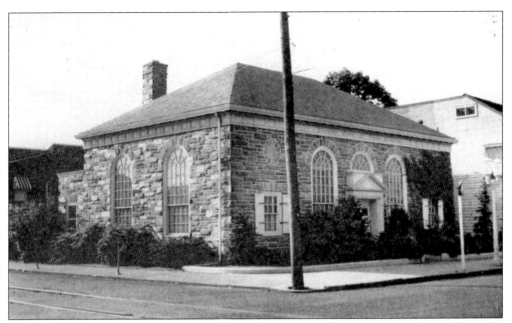

Shown in 1955, the Citizens Bank and Trust Company building was erected in 1942 at the southeast corner of Union and Brown Streets. It replaced a smaller bank that was built there on land purchased from a Mrs. M. B. Rambler by the company when it was organized in 1905. Druggist John W. Rewalt was selected as its first president. At that time and until 1924, the organization was called the Citizens National Bank. (Courtesy of the Middletown Public Library.)

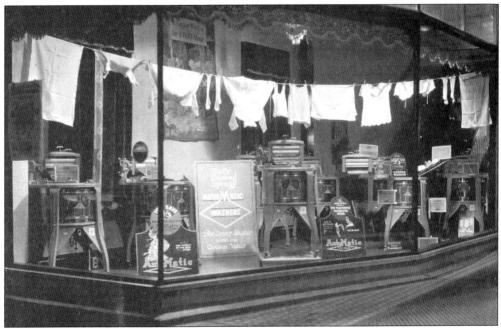

South Union Supply, located at 220 South Union Street, offered Automatic washers, using the slogan "the copper washer with the golden value." This was the store's display window in the 1950s. Kelvinator, RCA, and Sylvania products were sold, offering both sales and service for televisions.

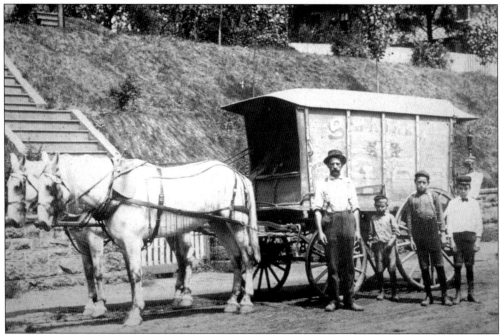

On West Main Street in this photograph from about 1900, the Swatara ice wagon is followed by children looking for ice chips.

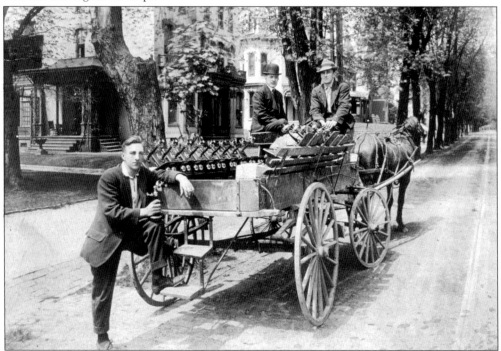

Shown on North Union Street, this telephone wagon traveled all over town to hook up residential telephones early in the 20th century. On July 4, 1903, Bell Telephone was given permission to remove the electric light poles on Union Street from Emaus Street to High Street and to replace them with its own poles.

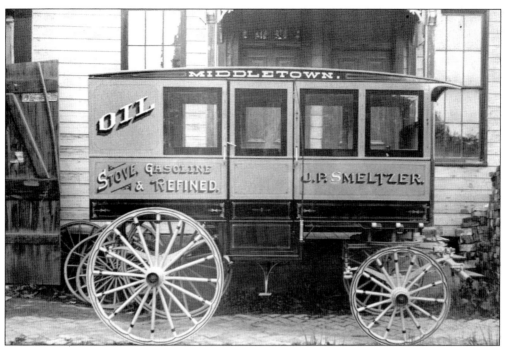

John P. Smeltzer's carriage advertised his Middletown Oil, Stove, Gasoline and Refined business. In the first decade of the 1900s, Smeltzer was listed in the business directory simply as an "oil dealer." (Courtesy of the Press and Journal.)

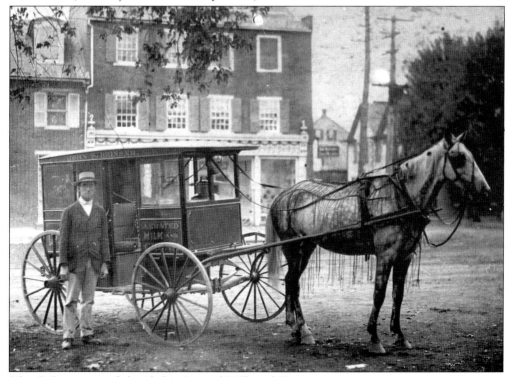

John S. Brinser stands beside his Aerated Milk and Cream wagon.

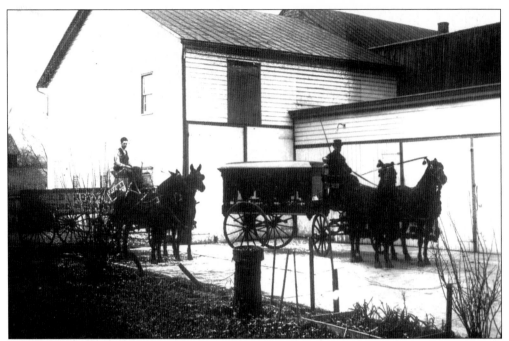

Parked near the Horatio S. Roth homestead on North Spring Street in the early 1900s is Roth's horse-drawn furniture delivery wagon and his hearse.

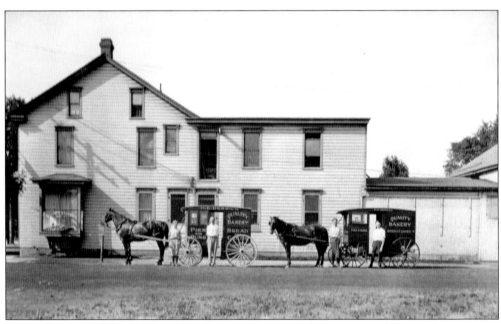

Harvey Elmer Derrick's Quality Bakery was at the corner of Lawrence and Wilson Streets. Here he shows off two horse-drawn delivery wagons in front of his shop. One of his advertisements touted, "Bread, rolls and buns—fancy cakes a specialty." He was still in business in 1925.

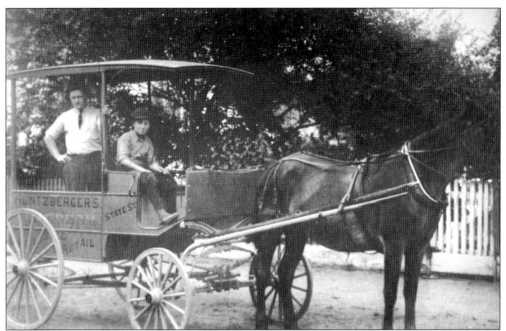

Shown standing in his fancy conveyance, Amos L. Huntzberger made ice cream at his 43 West State Street ice-cream factory store. A June 11, 1904, *Middletown Journal* entry informed the public, "A. L. Huntzberger is building a 16-by-18-foot addition to his ice cream manufactory on State Street." Later he moved his business to Swatara Street. Huntzberger died in 1938.

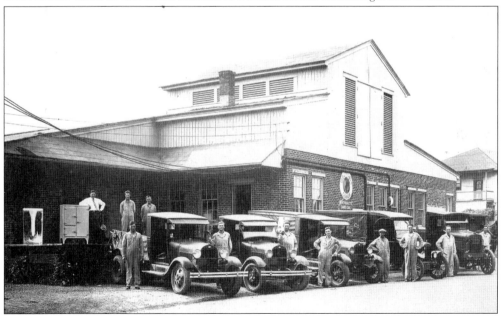

The Middletown Ice and Coal Company on South Race Street had these five trucks and one horse and wagon to haul ice to customers in the early 1930s. From left to right are (on the platform) plant owner Ralph Meckley, John Snavely, and Harry Balmer; (by the vehicles) Arthur Shaffer, Charles "Tut" Klinefelter, Gerald Shaffner, Charles Baker, Springer Weirich, "Toots" Bamberger, Cloyd Tressler, and Jack Shaffner.

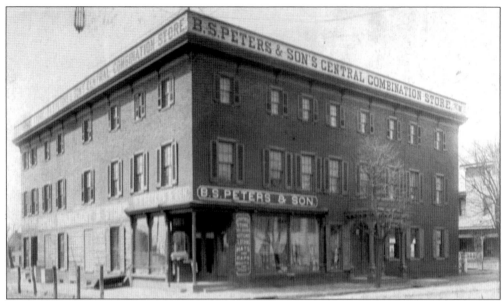

This is B. S. Peters and Son's Central Combination Store at the corner of Ann and Union Streets. An 1891 advertisement for this three-floored dry goods store proclaimed, "We name no prices, but will give you a price that always wins." Furthermore, its items "will be sold for a mere song compared with anything you have ever seen before." And it boasted, "Dutchess Pantaloons a Specialty." The store had vacuum tubes to send money directly to the office. (Courtesy of the Press and Journal.)

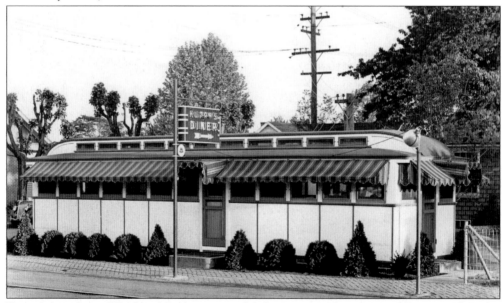

Kuppy's brand-new Ward and Dickerson–model diner graces the corner of Brown and Poplar Streets in this 1938 photograph. It was like the Cadillac of diners back then. In the early 1960s, it was bricked over, and a dining room addition was constructed. Four generations of Kupps have owned and run the diner, including, in order, Percy, Karl, Karl Jr., and Greg. Kuppy's Diner has continued into the 21st century as a popular Middletown restaurant. (Courtesy of Karl Kupp Jr.)

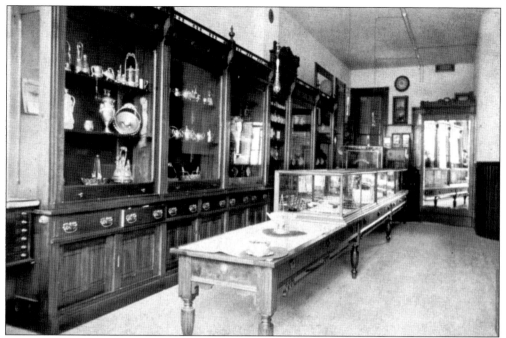

This is the interior of Klahr's Jewelry Store at 25 South Union Street prior to 1910, when the great downtown fire destroyed the building. The business was started in 1885 by Elias H. Klahr, rebuilt after the fire, and continued by his son Beane D. Klahr throughout most of the 20th century. It advertised as the "diamond counselors."

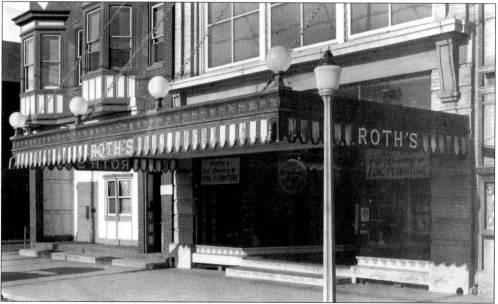

Horatio S. Roth founded his furniture store business in 1894. He discontinued an Ann Street site in 1909. His longtime 29 South Union Street site also housed a funeral home that he directed with his son H. B. Roth and a daughter-in-law. His furniture slogans included, in 1931, "for service, beauty and low cost—Roth's furniture," and in 1955, "whenever you think of furniture, think of Roth's." Roth's also sold typewriters, sweepers, and kitchen appliances.

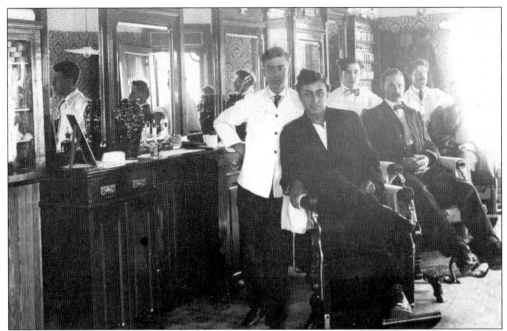

This is the interior of Nathan Fuhrman's barbershop on South Union Street. One of his promotional advertisements beckoned, "If you want to be treated right, call on N. C. Fuhrman, the S. Union St. barber. A clean towel used to every man." Fuhrman was in business in 1904 when the great ice flood in March caused him a loss of $100 in furniture.

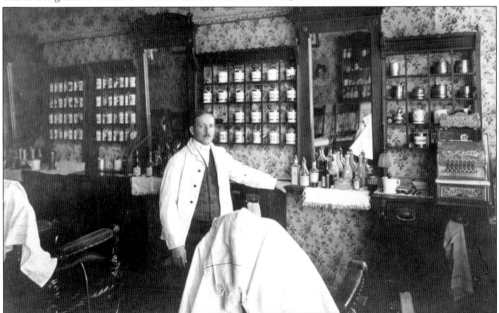

Charles R. Poist poses proudly in his barbershop at 108 South Union Street, perhaps around 1910. His customers' own mugs and brushes are on the shelves. His obituary in the March 3, 1944, *Middletown Journal* read, "Charles R. Poist, 69, a barber for the past 56 years, had been ailing since July but was able to be in his shop until the end of December. He learned the barber trade when he was 13 years old. He had married Charlotte Hipple of town in 1896."

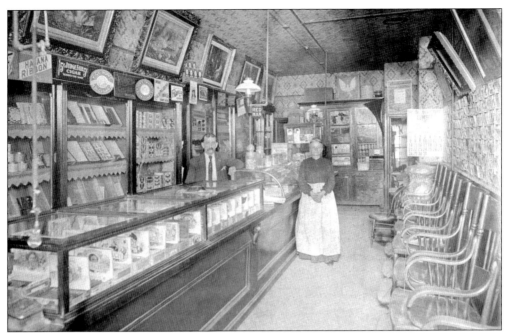

Frank A. Parthemore's tobacco shop at 104 South Union Street in the early 1900s offered chairs to its male clients for smoking and talking. In a 1913 advertisement, "cigars, tobacco and cigarettes, souvenir postcards, and stationery" were offered for sale. He also sold sporting goods. Parthemore died in 1942 at age 82.

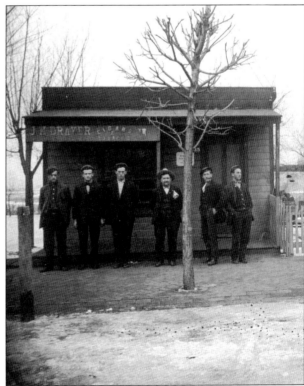

In this photograph from about 1900, six men are spending time outside Jacob K. Drayer's tobacco shop at 635 South Wood Street. Drayer is actually listed as a grocer in the 1909 and 1910 town business directories. He died in 1914. In a 1920 business directory, George H. Cain is listed as the owner of a grocery store in this building.

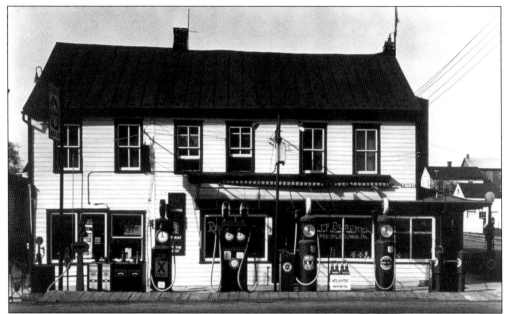

In 1919, the business at the northwest corner of Main and Race Streets in a building erected in the late 1700s or early 1800s became the Jacob Blecher Restaurant. In the 1800s, it was a general store owned for a number of years by Lewis Hemperly and then his son Luther until 1902. From 1902 to 1919, it was the Isaac Espenshade Quick Lunch Restaurant. Known popularly as the East End Restaurant, it later became Siler's Bar until 1980 and then Demp's Corner Pub.

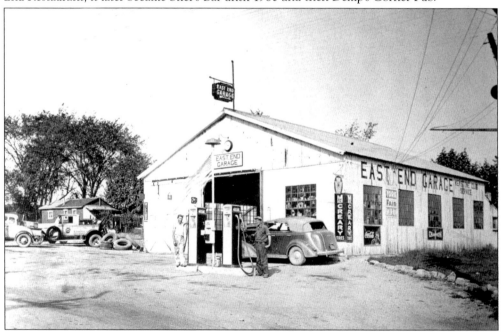

In a 1926 advertisement, Elmer E. Nissley's garage at the northeast corner of Vine and Main Streets offered Oaklands, Pontiacs, and Chevrolets for sale. Nissley built this establishment, the town's first modern retail and service station, in 1920. By 1937, this East End Garage was owned by Earl Heister. It is still in operation.

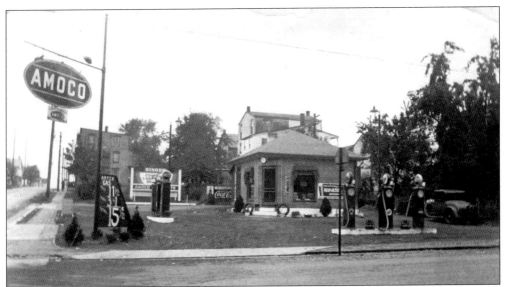

Abraham Singer, who was born in 1901 and was a member of the Middletown High School class of 1920, built his gas station at the northwest corner of Wood and Wilson Streets in 1931, the year he married Sarah Thelma Friedman. He sold Amoco gasoline and products there until 1960. By then, his son Stanley Singer worked in the family business that morphed into a B. F. Goodrich store, offering televisions and appliances. That business ended in 1974. (Courtesy of Stanley Singer.)

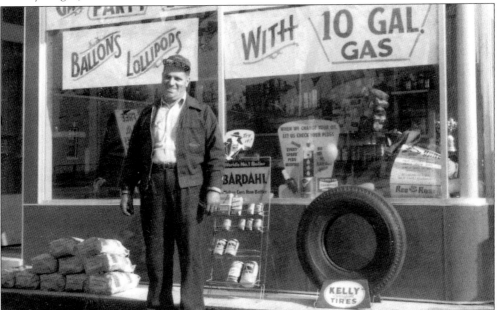

Elwood C. Seiders stands in front of his Sunoco station at the southeast corner of Main and Catherine Streets during a 1957 promotional offering. A lifelong resident of Middletown, Seiders began working at the Sunoco station in 1948 for Walter Detweiler, who started the business. Seiders continued working under new owner William Deimeler from 1950 until he became the owner in 1957. Elwood's Sunoco continues as a family business today. (Courtesy of Elwood C. Seiders.)

Oscar Edward Long's grocery store was at 121 North Catherine Street for many years, beginning around 1900. His residence was nearby at 113 North Catherine Street. Long died in March 1951 at age 72. His store building was razed in 1987.

Probably not long after E. W. Seiders started his grocery business in 1906 at the northwest corner of Union and Water Streets, these people and Seiders's horse and wagon stand in front of the store. Note the Eat Tip-Top Bread sign on the wall. A 1926 advertisement boasted, "Only the Best" and "Say no more, see us." Seiders lived at 303 North Union Street, next door to his business.

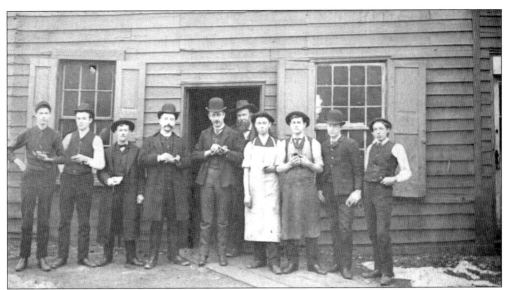

J. W. Stofer (with the long beard) poses with his newspaper staff sometime between 1870 and 1885 in front of his office, most likely in Smith's Hall at 239 North Union Street. Stofer purchased H. S. Fisher's weekly *Central Engine* publication in 1853, which was started by Fisher in 1851 as the *Swatara Gem*. Stofer changed its name to the *Dauphin Journal* in 1856 and then to the *Middletown Journal* in 1870. Stofer's employees are holding items indicative of their particular jobs. A. L. Etter purchased the newspaper from Stofer in 1885. (Courtesy of the Press and Journal.)

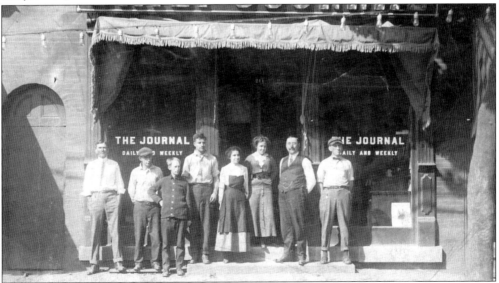

In the early 1900s, these were the staff members of the *Daily* and *Weekly Journals* at 215 South Union Street. The *Daily* was started in 1890. From left to right are Harry Fox, Titus Beard, C. R. Bausman, James Dougherty, Mae Ruth, Frances Lingle, Etter (owner and publisher), and Ted Lutz. Fox purchased the business in 1924, moving the printing machinery to 109–111 Poplar Street in 1927. When Fox died in 1935, his children Louise F. Graybill and J. Henry Fox took over. In 1944, they purchased the *Press*, dropped the *Daily Journal*, and began publishing a combined weekly, the *Press and Journal*. (Courtesy of the Press and Journal.)

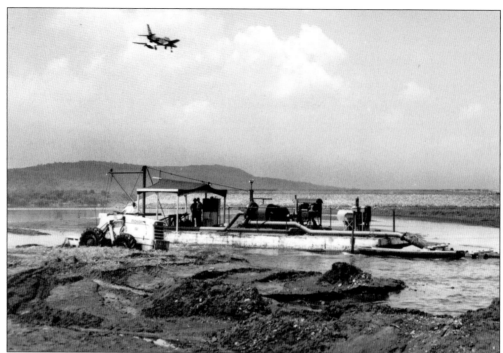

This photograph shows coal being dredged from the Susquehanna River for use at Metropolitan Edison Company's Crawford electricity-generating plant. Beginning operations in 1924, Middletown's Crawford plant was one of the first in the country to burn pulverized coal in its boilers. Anthracite coal particles deposited at riffles along the riverbed were reclaimed, the particles having floated downriver from coal-mining regions in northeastern Pennsylvania. (Courtesy of the Middletown Public Library.)

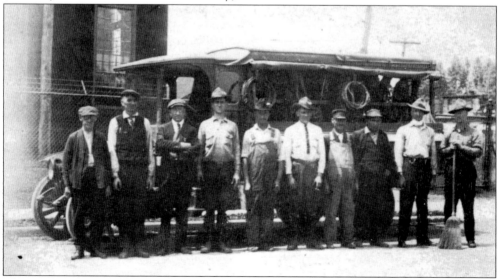

The Metropolitan Edison Company line gang poses at the substation on South Wood Street around 1920. From left to right are Clint Painter, Al Hornig, Erney Spangler, Edward "Blinker" Meinsler, William Bracht, Richard Earl "Spike" Wright, Al Pickel, Mike Strauss, Sam "Brandt-7" Brandt, and Ray Schrauder. (Courtesy of the Middletown Public Library.)

Five

STREETS AND PLACES

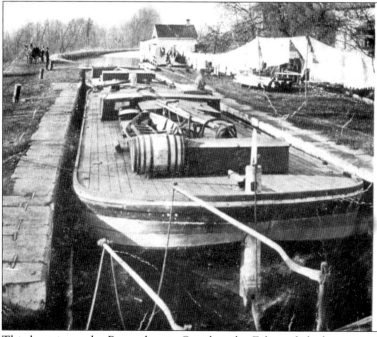

PENN'A CANAL
ALONG THE
SUSQUEHANNA

LOCK AT
FALMOUTH,
PA.

L. B. HERR PRINT

This boat is on the Pennsylvania Canal at the Falmouth lock just south of Middletown. This lock and the other two in the area, located at Bainbridge and New Holland, were needed to overcome the Conewago Falls, a 19-foot drop along the Susquehanna River. Built in the late 1820s, the east–west section of the Pennsylvania Canal connected Columbia in Lancaster County with Hollidaysburg in Blair County; goods could be transported between Philadelphia and Pittsburgh, with railway links at either end.

This was a section of the Union Canal below the towpath/Reading Railroad tracks at Hoffer Park. The canal, completed in 1828, was 79.5 miles long, connecting the Susquehanna River at Middletown with the Schuylkill River at Reading and following Swatara and Tulpehocken Creeks. Built at a cost of $6 million, it had a total of 107 locks. It was abandoned in 1885. The Reading Railroad was completed in 1890; the tracks are still used for summer pleasure excursions.

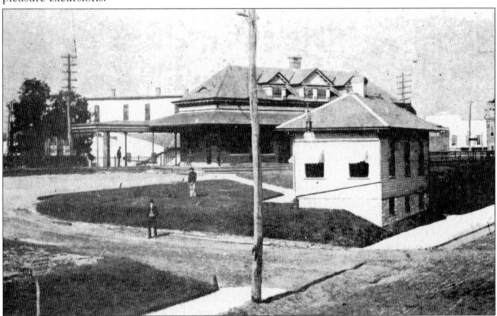

In 1836, the Harrisburg, Portsmouth, Mount Joy and Lancaster Railroad opened. Around 1850, the recently formed Pennsylvania Railroad took over the line. This brick and stone railroad passenger depot on Mill Street was built around 1902. It was torn down in the 1970s. In 1990, Amtrak constructed a shelter and a concrete platform at the site. The small white building in front was the stationmaster's house. (Courtesy of Grace I. DeHart.)

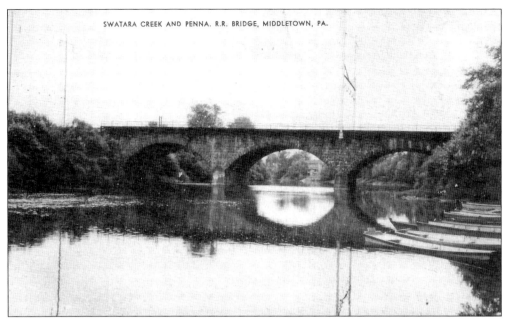

This is the stone, four-arched Pennsylvania Railroad bridge over Swatara Creek. On December 10, 1852, train cars first ran through, crossing the bridge, from Philadelphia to Pittsburgh. On the east side at Royalton, the Mount Joy and Columbia divisions of the railroad join before passing over the bridge. Frey's Mill is visible through the central arch of the bridge. A pedestrian passageway was constructed alongside the bridge in 1903. (Courtesy of Grace I. DeHart.)

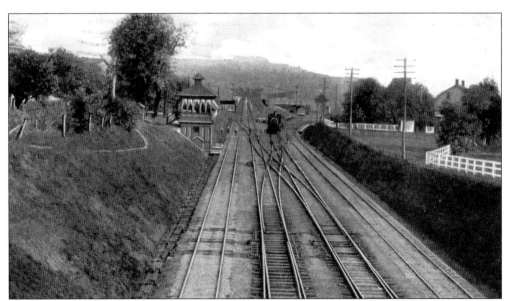

The "diamond," where one railway crosses another, is in this section of the Pennsylvania Railroad looking east from Royalton's Burd Street bridge in the early 1900s. The switching tower is on the left. Sunset Hill is in the background. (Courtesy of Grace I. DeHart.)

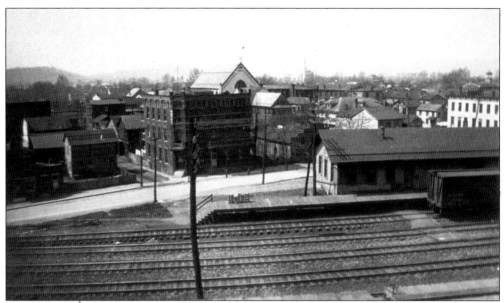

The Pennsylvania Railroad freight station was on Wilson Street, just west of Union Street. The old Wesley United Methodist Church is visible behind it. (Courtesy of the Press and Journal.)

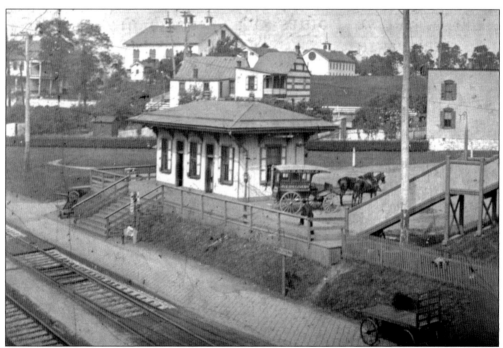

This view looking from the southeast toward the northwest shows the Pennsylvania Railroad's West Main Street train station, located at Col. James Young's farm, where a couple of his farm buildings with steeples are visible at the top. The steps leading up to the bridge over the railroad tracks connecting West Main to Wilson Street are on the right. Note the horse and carriage with its printing, "Myers Livery, Travel to All Parts."

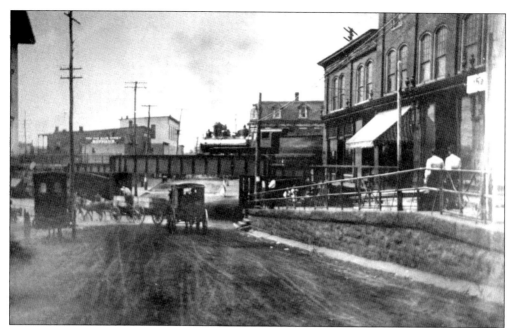

This early-20th-century view of South Union Street showcases an active spot in old downtown Middletown, with the subway, the train on the bridge, the horses and carriages, and the two dressed-up women on the sidewalk.

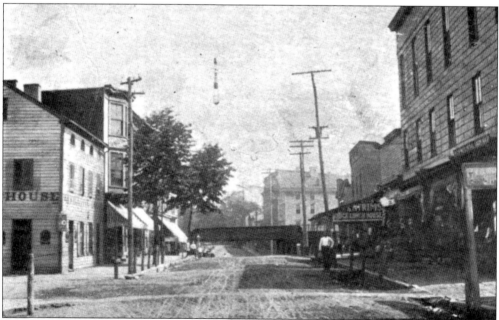

Taken between 1902 and 1918, this view looking north up Union Street shows the subway, Antrim's Quick Lunch restaurant, and the Washington House hotel at the northwest corner of Ann and Union Streets. One of Middletown's most prestigious citizens, Col. James Young (1820–1895), helped his father run the historic Washington House hotel in 1835 at age 15. Two early-20th-century proprietors were a Mrs. Harry Foltz and Christian Etnoyer. (Courtesy of Grace I. DeHart.)

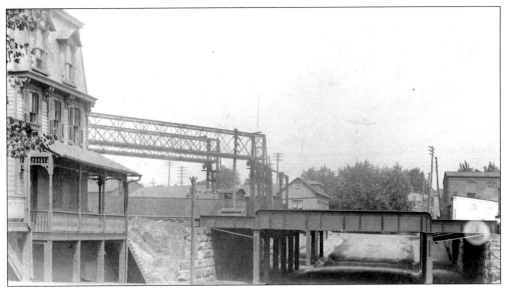

This photograph from about 1907 is looking north along Wood Street. The underpass subway, constructed in 1902 at the same time as the one on South Union Street, allows for passage of the Pennsylvania Railroad above. In July 1903, the *Middletown Journal* reported, "The stone wall that is being erected at the Wood Street subway is assuming large proportions and in a short time the iron work will be put in." (Courtesy of Grace I. DeHart.)

This was the Milligan home at the southwest corner of Pike and Catherine Streets around 1900. In a November 14, 1903, recollection piece in the *Middletown Journal*, an "F.O.W.," who grew up in the Portsmouth area in the mid-1850s, recalled the Milligan home: "The old pump remains—how many hundreds of buckets we carried from that pump, and what a horror of washday we had."

This is a view from about 1907 of Ann Street looking west. It is in Middletown's First Ward, the most southern part of the community, on the western side of Swatara Creek as it nears the Susquehanna River. Before the area's consolidation with the borough in 1857, it was called Portsmouth from about 1814, and before that Harborton, when George Fisher Jr., son of the founder of Middletown, laid it out as a separate town in 1809. (Courtesy of Grace I. DeHart.)

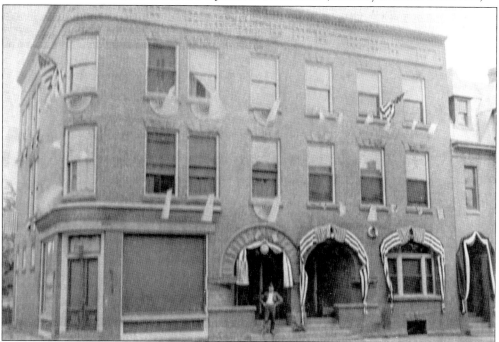

Cameron's Castle at 65 Ann Street was built around 1891 in the once-fashionable Middletown neighborhood by Cameron Young, a prominent citizen and businessman, who lived there until 1903. Its name was an outgrowth of a family joke referring to Young's pretentious taste. This three-story redbrick and brownstone house has Victorian-style arches at the front entrance. The next owner, William Rank, started his glove company there in 1908.

The Ferry House on South Union Street is the only known surviving one-and-a-half-story log house in Dauphin County. Deeds prior to 1827 reserved the right to operate a ferry across Swatara Creek to lot 62, suggesting that the building was there by 1812. And tradition has it that it began life as a trading post from about the beginning of the 18th century. Listed on the National Register of Historic Places, the Ferry House (also called the Fort or the Barracks) was purchased by the Middletown Historical Society in 1981.

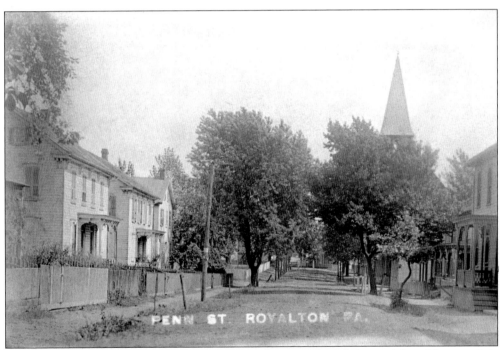

Penn Street in Royalton in the early 1900s was a dirt, tree-shaded thoroughfare. The steeple is that of the Emmanuel United Brethren Church, erected in 1893, later becoming the Emmanuel United Methodist. The pastor in the early years was Rev. H. D. Lehman, who was married to Ella Deem. In 1970, the structurally weakened sanctuary was razed, and a new house of worship was erected on the site.

The view north along Wood Street in the early 1880s shows private residences on the left, the Pennsylvania Railroad tracks (the subway was not constructed until 1902), and the Middletown Furniture Company factory (1873–1922) on the right, which later became the Penbrook Candy Company (1948–1959), at the intersection with West Emaus Street. Penbrook shipped its hard candies (principally lollipops) to 42 states and several foreign countries.

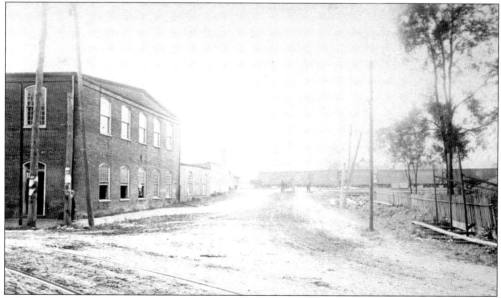

A look south along Wood Street in the 1880s reveals trolley tracks and the Middletown Furniture Company on the left at the corner of West Emaus Street. One of the leading businesses in town at the time, the company manufactured high-quality and artistically designed armchairs and bedroom suite furniture and, later, cabinets and furniture for banks, churches (including the pews for St. Peter's Lutheran Church), stores, and post offices. During the hard times following World War I, the company closed.

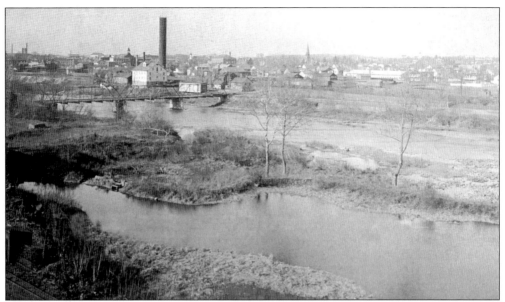

This fine pre-1910 view of Middletown is from the Middletown Country Club on the hill across Swatara Creek in Royalton. The iron Grubb Street Bridge crosses the creek. The large Walter Kendig, John Bricker, and William Lauman lumberyard smokestack is visible, with Frey's Mill directly in front of it. From left to right just below the skyline are the Pennsylvania Railroad depot, the Raymond and Campbell bell tower, the large Middletown Auditorium building, and the St. Peter's Lutheran Church spire.

The Swatara Creek feeder dam, across from what is now the west end of Hoffer Park, furnished water for the Middletown Electric plant (visible with its smokestack) and surplus water for the Pennsylvania Canal at the first, or Neff, lock. This photograph was taken about 1903 from the Royalton end of the dam. Middletown resident John Kieffer, recalling his childhood days in the 1920s, noted, "The best swimming hole in the world was at the dam."

This building just inside the entrance to Hoffer Park was erected in 1893 for $28,000 as the Middletown Electric power plant. It was abandoned in 1906 when the town began getting electricity from the York Haven Power Company, which later became the Metropolitan Edison Company. In 1914, it was renovated to become a spacious park pavilion. It was finally razed around 1970.

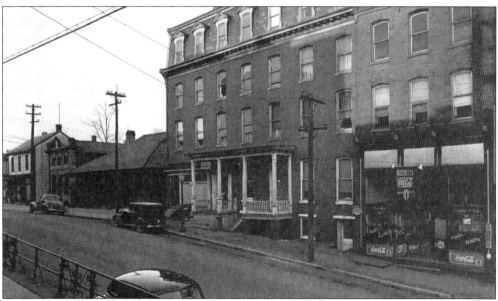

The Kline Building (named after Harry H. Kline), located at 134–138 South Union Street in the 1940s, had signs advertising Kline House rooms and a poolroom. It was a popular hotel and restaurant in 1904, when a January 2 issue of the *Middletown Journal* mentioned a successful dinner held there: "Eight covers were laid for 28 guests and the dinner was served in the style which has made the reputation of the Kline House." In 1913, William W. Conklin was listed as the proprietor.

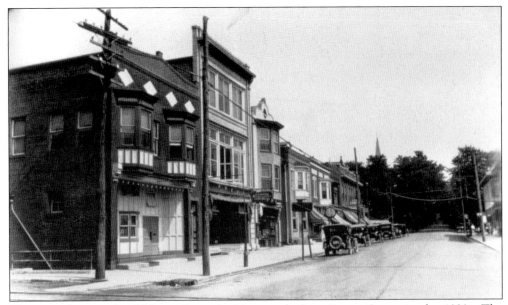

This is a photograph of Union Street looking north from Brown Street in the 1920s. The St. Peter's Lutheran Church spire is visible. It is believed that Union Street, which boasts the community's main downtown business district and some of its fanciest homes north of the Emaus Street intersection, received its name because it connected Middletown to Portsmouth.

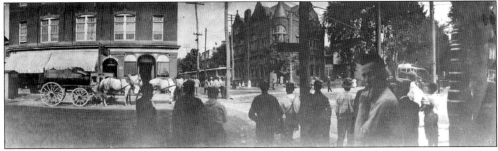

This three-photograph combination shows the corner of Union and Emaus Streets before 1910. Note the Middletown Auditorium (with the post office sign in the lower right window), the Atlantic Refining Company four-horse wagon, the multiple trolleys, the Farmers' Bank, Baxtresser Brothers shoe store, the café, and the Ice Cream Bricks sign on the shed in the street. The crowds of people demonstrate that this was a special day, or at least a very active one, in Middletown's past.

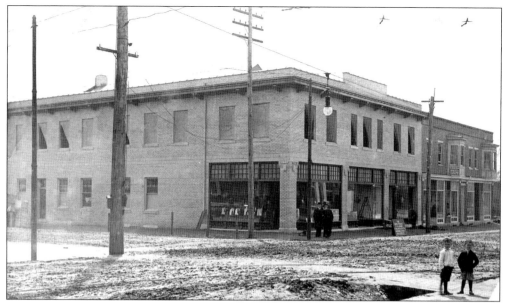

This is the intersection of Union and Emaus Streets near the completion of the rebuilding of the downtown area after the great fire of 1910. The men are standing by the new Rewalt Building; the boys are in knickers at the Farmers' Bank corner. Note the ladder in the one window, the worker with his wheelbarrow and tools, and the installation company signs on the sidewalk and up on the second building. (Courtesy of the Press and Journal.)

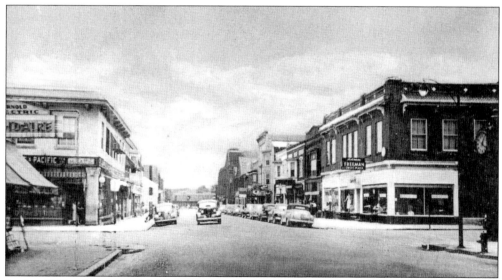

In the 1940s, downtown Middletown was flourishing. At the southeast corner of Union and Emaus Streets was the A&P. At the southwest corner was Melman's shoes and merchandise store. Note the Seth Thomas street clock on the northwest corner; the Mothers Congress Circle had gathered funds for its purchase in 1923 to honor the men from town who had served in World War I. (Courtesy of Grace I. DeHart.)

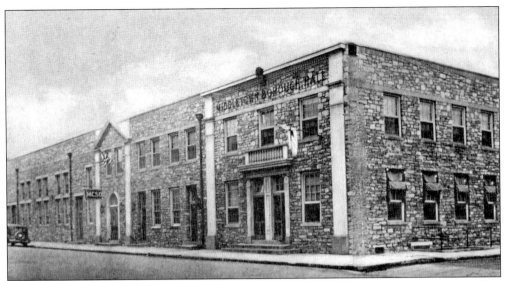

At the corner of Emaus and Catherine Streets, Middletown Borough Hall was erected in 1910 after the great fire of April 9. It originally housed Romberger Hosiery Mill from 1917 to the mid-1930s. In 1934, the borough purchased the building, and in 1936, it was remodeled by Works Progress Administration workers and became the borough's office and a community center, with the Middletown Community Service Organization formed and centered there after World War II. (Courtesy of Grace I. DeHart.)

The Elks building, which got its name after the organization bought it in 1931 for $67,000, replaced the Middletown Auditorium at the southwest corner of the intersection of Union and Emaus Streets after the fire of 1910. Doutrich's clothing store rented out the corner first floor, with the Elks lodge rooms on the second floor. The horns of the elk's head mounted on the wall lit up at night. (Courtesy of the Press and Journal.)

Isaac O. Nissley (1854–1918) poses at his 48 North Union Street residence around 1915. Nissley bought J. R. Hoffer's publication, the Middletown *Press*, in 1882, one year after Hoffer started it. In 1927, with C. G. and J. C. Nissley now running the publication, it was touted as "Dauphin County's Best Farmers' Paper" and had a weekly circulation of 4,600. Isaac O. Nissley was also a prominent member of St. Peter's Lutheran Church, becoming Sunday school superintendent.

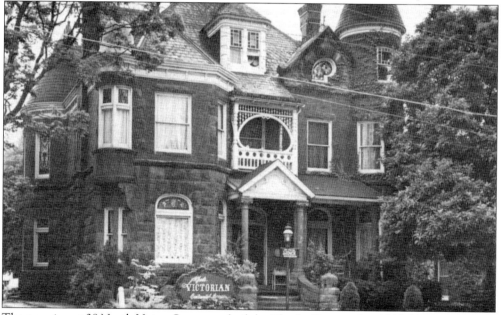

The mansion at 38 North Union Street was built by Charles Raymond in 1888. He was a partner in the Raymond and Campbell Stove Works in town. Constructed of brownstone from the nearby Hummelstown Quarry, this Victorian structure features fine interior woodwork, stained glass, and priceless chandeliers. Listed on the National Register of Historic Places, it became Alfred's Victorian Restaurant in 1970.

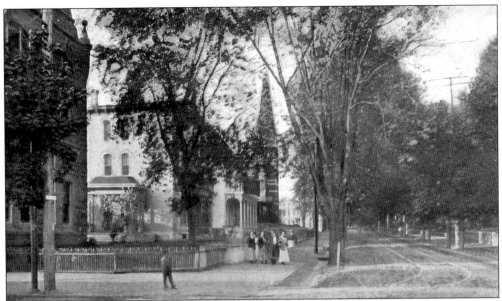

This photograph from about 1909 shows North Union Street from the corner of Emaus Street. The Farmers' Bank, with its iron fencing, is on the far left. Next to it, erected in 1836, is the home of James Campbell, who owned a machine works in Middletown in the 1800s. A portion of this house, which had over 30 rooms, was used by Olmsted Air Force Base as a United Service Organizations (USO) headquarters during World War II. Farther up the street is St. Peter's Lutheran Church. (Courtesy of Grace I. DeHart.)

At the corner of Spring and Union Streets, this triangular-shaped building housed the Middletown Post Office from 1876 until 1893. For just a couple years at the end of the first decade of the 20th century, it was a millinery shop. Then from 1923 to 1945, it was George Knupp's Triangle Grocery Store, featuring homemade ice cream. It remains standing today as an apartment house. (Courtesy of Grace I. DeHart.)

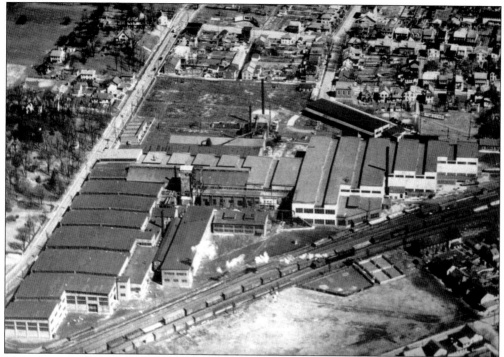

This is an aerial photograph of the Middletown Car Works, the Pennsylvania Railroad, and a western section of town along West Main Street. In 1930, the car works' buildings were purchased by the Coatesville Boiler Works, which mainly manufactured fire tube boilers and steel-plate work for industries. It closed during the Great Depression.

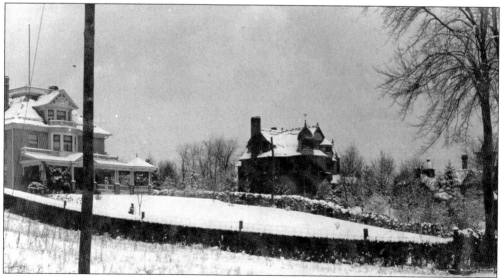

Snow on a winter day accentuates the beauty of these fine homes on the hill along the north side of West Main Street. From left to right, the first three houses were built in the late 1800s by members of the Matheson family, owners and operators of the American Tube and Iron Company, located on the south side of West Main Street. Before these fine homes were built, the land was part of the Col. James Young estates. (Courtesy of Grace I. DeHart.)

Five Peaks (also known as Five Points) was a row of five gable-pointed houses at the southwest corner of Catherine and Main Streets. It was Middletown's station for the Underground Railroad, with groups of blacks arriving by way of Harrisburg and Chambersburg, including the Stanton, Noon, and Brown families. The Fisher and Crow families in town were instrumental in the conduction and supervision of this station. The buildings were razed in 1937.

Congressman Jacob Rife owned the house with the fancy woodwork at the northwest corner of Spring and Water Streets. His tannery was located behind the home. It later became known as Dr. Oliver H. Swartz Sr.'s home and office. In 1942, a U.S. Army Air Corps P-38 fighter plane crashed into the yard on the north side of the dwelling. (Courtesy of Grace I. DeHart.)

The southeast corner of Main and Spring Streets is snow covered on this fine day early in the 1900s. Walter E. Baxtresser's house is on the left, built in 1851 by John Watson. Residents who disapproved of his idea of elegance called it "Watson's Folly." Built of red brick, it has Doric half columns on each side of the front entrance.

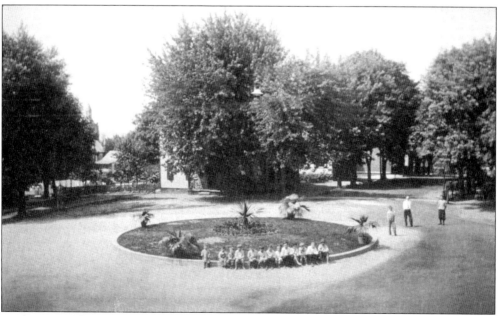

At the time of this early-20th-century photograph of Center Square (at Main and Union Streets), large, beautiful trees dominate the scene west down Main Street, with the kids on the edge of the popular curbed circle of flowers. At one time, there was a flag at Center Square and a couple of cannons. The visible spire is that of the First Church of God at the corner of Spring and Water Streets.

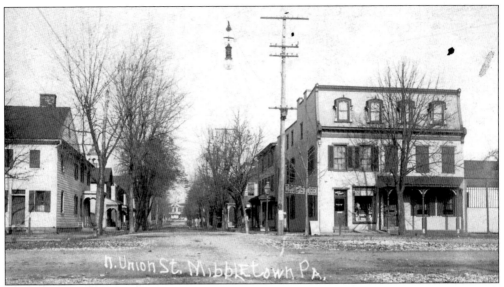

At the northeast corner of Main and Union Streets, the drugstore sign in this pre-1918 photograph identifies Dr. Eugene Laverty's home and the business that he ran from 1881 to 1960. In the distance at the far end of Union Street (where the road actually makes an S turn) is the house Abraham Landis built in the 1850s. It later became known as the "cemetery house," as it was purchased by the Middletown Cemetery Association for the graveyard caretaker's residence.

The George Frey house at 43 East Main Street, built by 1768, is named after George Eberhardt Frey (1732–1806), a German immigrant who started as a hired hand working for George Fisher, the founder of Middletown, and later became one of the wealthiest men in the community. He and his wife, Anna Catharine Spath, lived in this two-story Georgian brownstone home. At one time, the house had a general store and tavern in it. Today it is an apartment house. (Courtesy of the Middletown Public Library.)

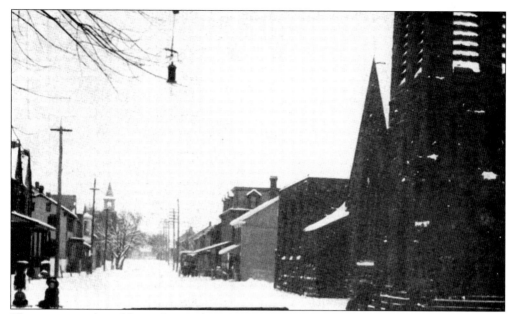

This view east from Union Street along Water Street was taken during a winter many years ago. In the foreground, across from the children on sleds, is the Presbyterian church. Visible down the street at the corner of Water and Spruce Streets is the United Brethren church, which became the United Methodist church in 1968. (Courtesy of Grace I. DeHart.)

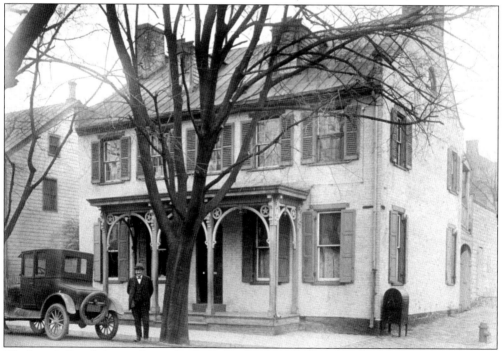

The Joseph Brestle house, located at 304 Pine Street on the corner with Water Street, was built in 1835. A cooper shop, erected in 1768 and owned by William Wandlass, had previously been at the location. Brestle constructed a number of other Federal-style homes on that Pine Street block in the 1930s.

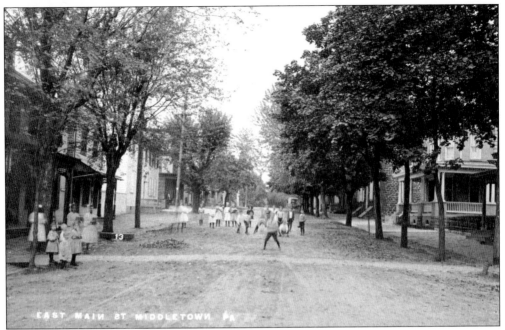

In this pre-1918 view of an unpaved Main Street from Pine Street, children play, taking advantage of the lack of much traffic in those days. The crosswalk was there to keep mud from pedestrians' feet when crossing the street. Passenger coaches could travel on this King's Highway between Middletown and Philadelphia at a rapid rate, covering the distance in just two days.

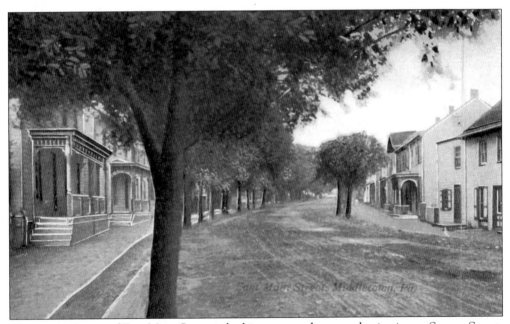

This pre-1918 view of East Main Street is looking east at the curve beginning at Spruce Street. One of only three east–west streets when the town was laid out (the other two being Water and High Streets), Main Street had brick sidewalks and beautiful trees lining it. Paving began in 1918.

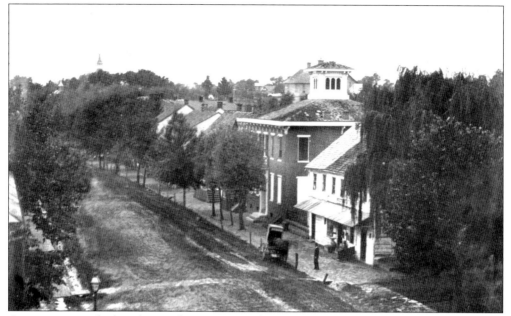

A carriage is parked at the northwest corner of Main and Race Streets in front of the Lewis Hemperly building, which was a general store before 1902 and the East End Restaurant later. This corner was one of the town's oldest business locations, with an inn, a stonecutter, a butcher shop, and a tavern all located there before the 1900s. The tower of old Sant Peter's Lutheran Kierch is visible in the distance.

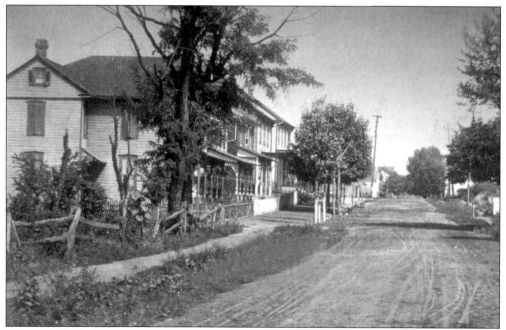

This view looks north on an unpaved Race Street very early in the 1900s. Race Street was one of the five north–south streets originally laid out for the town in 1755 by George Fisher. The other four were Vine, Duck (later renamed Spruce), Pine, and Main Cross (later renamed Union) Streets.

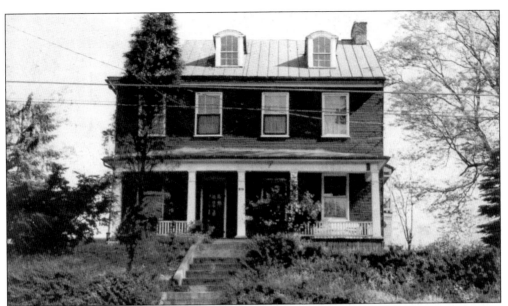

This George Fisher descendants' family home (erected between 1860 and 1875 and razed a century later) was on a hillside just a short distance west of the ford across Swatara Creek. Fisher arrived at the location in April 1752 after a five-day journey from Philadelphia in a train of three Conestoga wagons, each drawn by six horses and loaded with provisions and farming and building implements. His first structure at the site was a log cabin, then shortly afterward a larger log structure that stood until 1859. (Courtesy of the Middletown Public Library.)

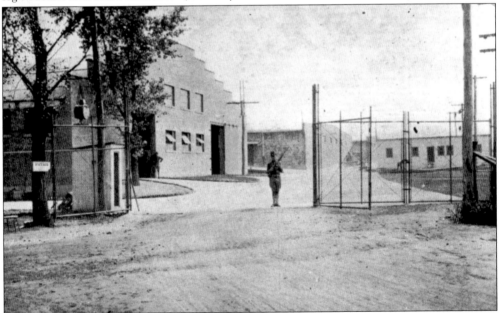

The Middletown Air Depot (later renamed Olmsted Air Force Base) was established under the Signal Corps of the U.S. Army in 1917. This photograph of a gate guard was probably taken not long after that beginning. Civilian employee numbers surged during World War II when the base was the largest plane engine overhaul center in the world. It played important roles during the 1948 Berlin Airlift and during the Korean War. (Courtesy of the Middletown Public Library.)

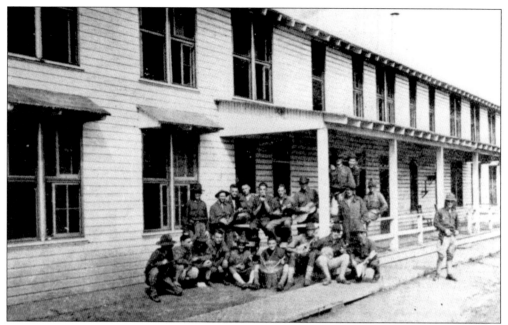

These soldiers pose for a little "musical interlude" photograph outside their Olmsted Air Force Base barracks not too many years after the base's opening in 1917. During and after World War II, the 1,150-acre base was the largest employer in the area, with over 12,000 employees in 1964. Civilians outnumbered the military 10 to 1. A phase-out announcement came on November 19, 1964, and the entire base was shut down by 1968. (Courtesy of the Middletown Public Library.)

This was the noncommissioned officers' mess hall at Olmsted Air Force Base. It was equipped with a ballroom, a dining room, a game room, a cocktail lounge, and a bar. By 1955, the base had nearly 900 military personnel assigned to it. In 1917, the base's first military men, including the 634th Aero Squadron, had a much more spartan life, living in tents and eating in a basically equipped mess hall. (Courtesy of the Middletown Public Library.)

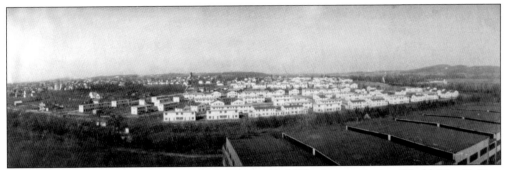

This is Pine Ford Acres and the roofs of the East End Warehouses during World War II. Pine Ford Acres was a federal housing project at the east end of Middletown, established just before the war. During the war, the warehouse complex was used for government storage.

Affordable housing in Middletown was scarce at the beginning of World War II. Many of the breadwinners at Olmsted Air Force Base had to commute from homes outside town, even as far as the coal regions of northeastern Pennsylvania, until federal housing at Pine Ford Acres became available. This is a photograph of Edward Sunbery in front of his family's home on Pineford Drive in 1948. Sunbery's father, Edward Sr., and mother, Eleanor, from Shamokin, both worked at the base. (Courtesy of the family of Eleanor and Edward Sunbery.)

Six

MOMENTS IN TIME

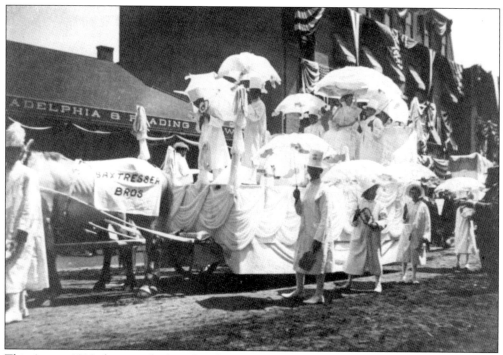

This August 1898 photograph along South Union Street is labeled "President McKinley Viewing Middletown Parade," with the president visible on the far right. He came to Middletown to inspect the newly completed Camp Meade, intended to be a permanent training camp for the U.S. Second Army Corps during the Spanish-American War. The Philadelphia and Reading Railway station is behind the Baxtresser shoe store float.

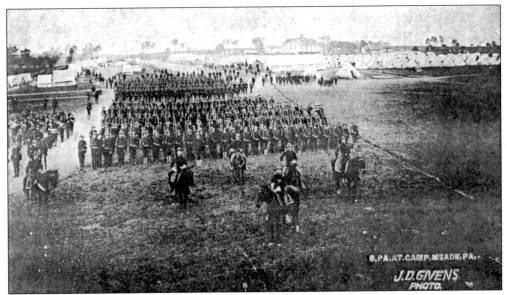

The troops of the 8th Pennsylvania Infantry Regiment, 3rd Brigade, 1st Division of Maj. Gen. William Graham's Second Army Corps stand at review in 1898 at Camp Meade, just west of Middletown. Established to train soldiers to become an army of occupation in Cuba during the Spanish-American War, the camp opened in mid-August only to close in mid-November with the ending of the war.

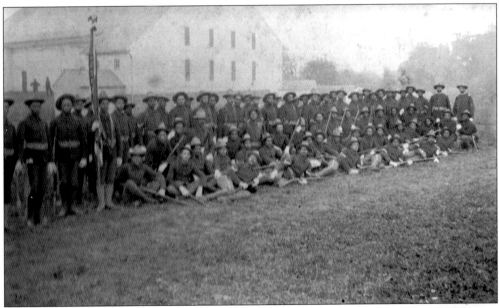

These Camp Meade soldiers pose in front of a barn that probably belonged to Middletown's Col. James Young, who owned nine farms west of town. Appropriating land that stretched for about three miles west from Middletown and three miles north from the Susquehanna River, the army drilled three artesian wells and took over an old tobacco warehouse, converting it into a bakery—all to attend to the needs of the approximately 25,000 men quartered there.

This crew, under contractors Sparks and Evans, is busy constructing the Wood Street subway under the Pennsylvania Railroad in 1902. The Middletown Furniture Company factory is visible on the right beyond the underpass, and the Middletown Car Works is on the left.

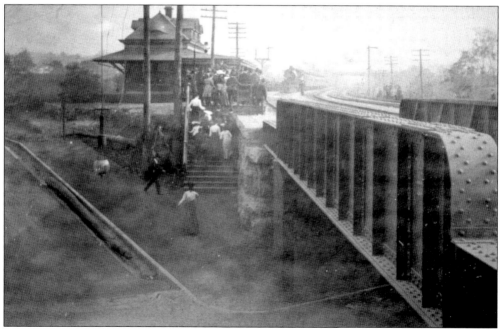

Middletown residents witness the first time that a train stopped at the new Pennsylvania Railroad passenger depot on Mill Street not long after construction of the subway in 1902.

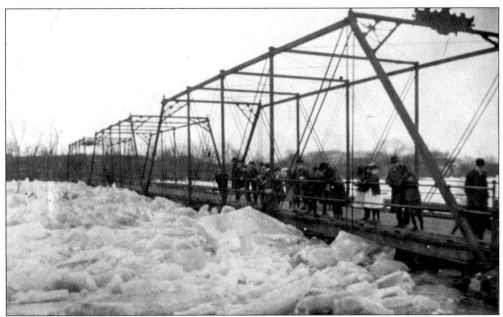

Residents view the ice flood of 1904 from the Grubb Street Bridge across Swatara Creek from Mill Street in Middletown to Royalton. Even before the flood, the February 27, 1904, edition of the *Middletown Journal* noted that the bridge had been "moved about eight inches in the center" by ice. Swatara Creek and the Susquehanna River had been frozen for a month from Harrisburg to Columbia. (Courtesy of Grace I. DeHart.)

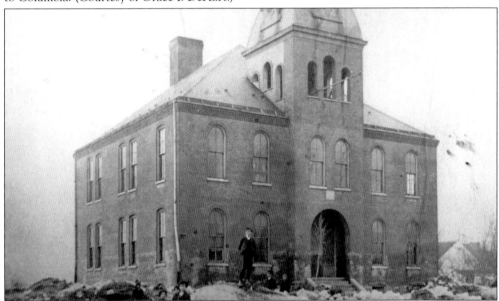

Children stand in front of the Susquehanna School at the corner of Wood and Pike Streets in 1904 after the March ice flood. Constructed in 1891 at a cost of $10,000, this building survived the flood and still stands today, but destruction in the rest of Middletown's First Ward was horrendous. The high-water mark of over 25 feet was actually 2 feet higher than the flood of 1936. It was reported that the water rose so rapidly that people had to leave their supper tables and flee for their lives. (Courtesy of Grace I. DeHart.)

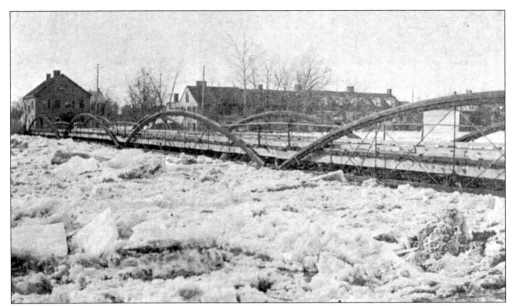

This is the Aqueduct Bridge from the east side of Swatara Creek during the March 1904 ice flood. The building on the far left is Haretan's Store, with the Mansion House next to it. According to the March 12, 1904, *Middletown Journal*, the bridge "escaped serious damage, but several rods were bent and twisted." In the Mansion House, which had been William Murray's tavern beginning back in 1852, proprietor John Snyder placed the piano on the bar, but it was still four inches in the water. (Courtesy of Grace I. DeHart.)

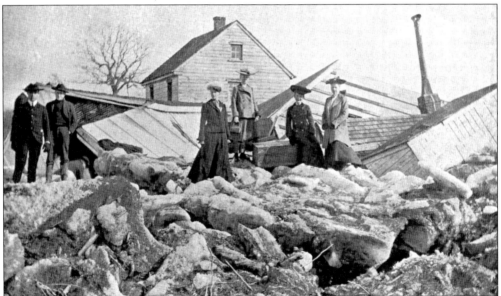

These men and women witness the devastation caused by the great ice flood of early March 1904. Edna Kurtz Groupe is the woman farthest to the left. They are standing by the demolished houses of the Mansberger and Stager families at the corner of Union and Susquehanna Streets. On March 4, the ice flood "struck suddenly as high water propelled monstrous ice sections against houses in the First Ward," with the buildings "crushed like eggshells," according to the *Middletown Journal*. (Courtesy of Grace I. DeHart.)

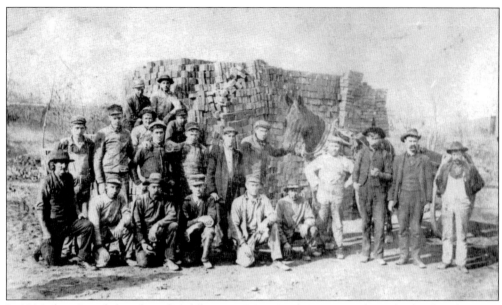

In 1904, these Jewish founders of Middletown's B'Nai Jacob Synagogue brought this first shipment of bricks from the Royalton Shale Brick Company brickyard to a 40-foot-by-60-foot plot of ground at the corner of West Water and Nissley Streets, purchased from C. H. Hoffer, to build their place of worship. Standing in front of the horse with arms akimbo is Philip "Pappy" Singer, who owned the horse and cart used to transport the bricks. (Courtesy of Larry Kapenstein and B'Nai Jacob Synagogue.)

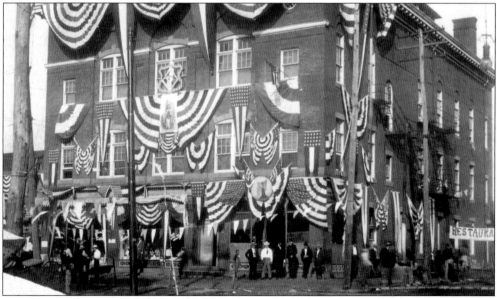

The Middletown Auditorium at the southwest corner of Union and Emaus Streets is really decked out for the Middletown sesquicentennial celebration of 1905. On Sunday, July 2, special religious services were held in all the churches. On July 3 at the fairgrounds, an industrial demonstration was held in the morning, horse races and an educational demonstration were held in the afternoon, and historical and musical entertainment took place in the evening, followed by fireworks.

The driver of this float in the grand sesquicentennial parade of July 4, 1905, is George Stuart. His passengers are Charles E. Seltzer and Seltzer's daughter Elizabeth. It was estimated that 5,000 people participated in the parade. A huge fireworks display ended the very memorable three-day sesquicentennial celebration that had been organized by patriotic citizens, including E. O. Hendrickson, C. S. Few, W. J. Roop, and Charles Henry Hutchinson (elected historian for the event).

This 1905 sesquicentennial view looks west up Main Street from the intersection with Race Street. Decorations abounded in town, with arches placed across streets by a number of businessmen. Business owners also decorated their stores, and patriotic citizens decorated their homes.

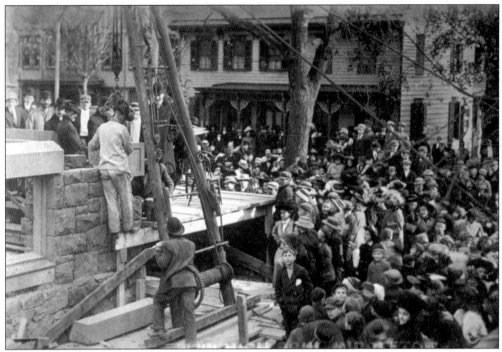

Many people witness the 1909 cornerstone-laying ceremony for the new Middletown High School on Water Street.

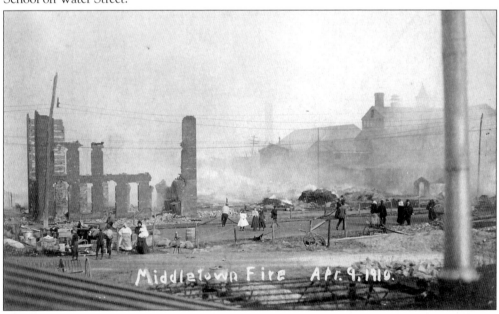

The great fire of April 9, 1910, destroyed buildings between Catherine, Emaus, Pine, and Brown Streets. "The heat was so intense that eyebrows, hair, and moustaches of the firemen were scorched, their faces and hands blistered," according to the *Daily Journal*. An estimated 20,000 people came on Sunday, April 11, to view the destruction, with trolley cars operating every 10 minutes, 2,500 arriving by railroad, and hundreds more by horse teams. The miraculously unharmed Raymond and Campbell Stove Works is in the background. (Courtesy of Grace I. DeHart.)

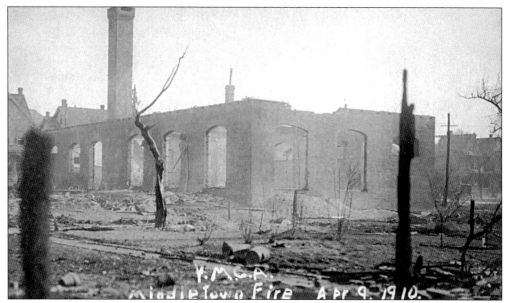

The YMCA, located on Emaus Street between Union and Pine Streets, succumbed to the horrendous 1910 fire. One witness, 10-year-old Beane D. Klahr, remembered, "I saw flames from the Market House [where the conflagration began] cross the alley and set another building on fire. The wind was strong [the Middletown *Daily Journal* reported a 'driving, 25-mile west wind carried clouds of dust']. Embers were carried and even barns outside of town were set on fire." (Courtesy of Grace I. DeHart.)

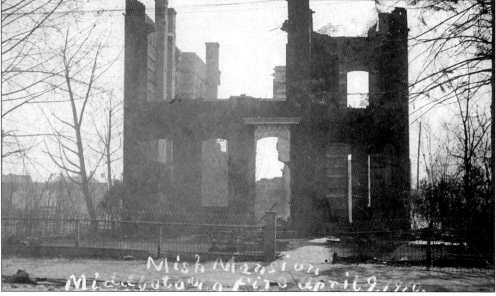

Dr. George F. Mish's mansion at the corner of South Union and Brown Streets, where the post office was later erected in 1936, was a total loss, listed at $13,000, in the calamitous fire of 1910. Mish was a well-known physician who had begun his practice in town back in 1855. His house marked the southern end of the fire, which had jumped across Union Street from the Middletown Auditorium, where the fiercest blaze was reported, to the Rewalt Building and then down Union Street. (Courtesy of Grace I. DeHart.)

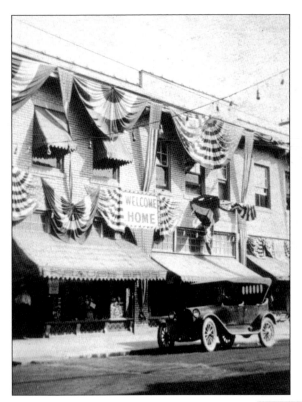

The Rewalt Building, housing the Krauss Brothers (Samuel and Max) clothing store at the time, is decorated for the 1919 celebration for returning World War I veterans. Approximately 450 men from Middletown, Royalton, and the surrounding rural area served, most in the 28th, 35th, or 79th Divisions of the Pennsylvania National Guard. Eleven were killed in action or died while in service.

In 1919, Liberty Steam Fire Company No. 1 on Catherine Street is decked out with flags to celebrate the return of the town's World War I veterans. The Mothers Congress Circle sponsored the welcome home celebration. During the war, the group participated in all war drives and made and presented comfort kits to all the boys from town who had entered the service.

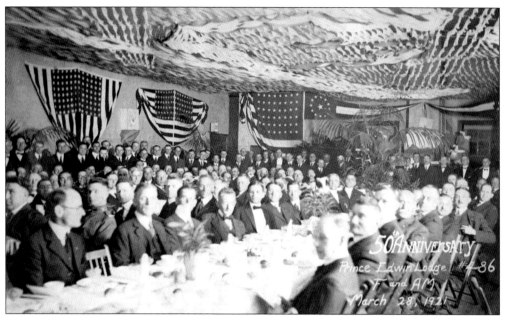

The Masons celebrate their 50th anniversary, commemorating March 27, 1871, the day when Robert A. Lamberton, right worshipful grand master, and a large number of other brethren constituted Middletown's Prince Edwin Lodge No. 486, Free and Accepted Masons. Monthly meetings for the previous 50 years had been held in rooms on the third floor of the Farmers' Bank building at the corner of Union and Emaus Streets.

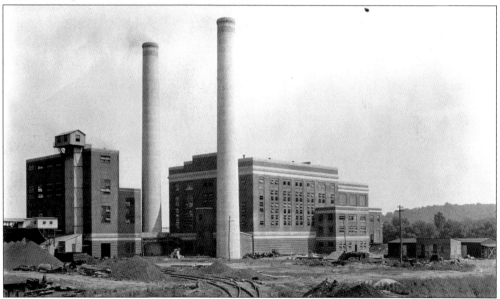

Construction of the Metropolitan Edison Company's coal-fired plant to generate electricity began in 1920. All excavation was done by pick and shovel, with the earth transported away by horse and cart. The plant began operating in 1924 as the Susquehanna River Station, with Harold Crawford as superintendent. In 1948, it was renamed the Crawford Generating Station in his honor. The station closed in 1977, in part due to the existence of the nearby Three Mile Island nuclear generating plant. (Courtesy of the Middletown Public Library.)

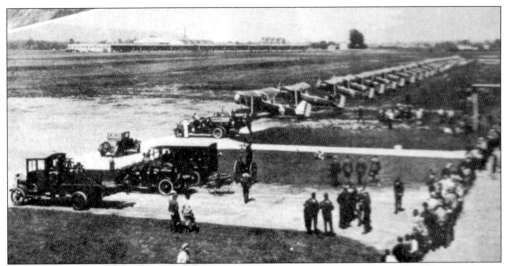

This 1923 photograph shows the fledgling U.S. Army Air Corps staging an exhibition at Olmsted Airfield. The field was named that year in honor of 1st Lt. Robert Olmsted (1886–1923). A balloon pilot, Olmsted was killed (along with his copilot Lt. John Shoptaw) on September 23, 1923, when his army balloon S-6 was struck by lightning and fell to earth in flames at Nestlerode, Holland, while he was participating in the 12th Gordon-Bennett International Balloon Race. (Courtesy of the Middletown Public Library.)

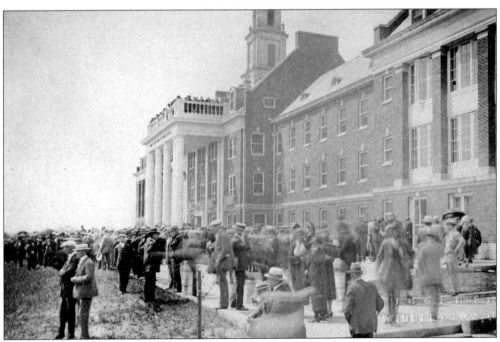

Many people attend the dedication of the Odd Fellows Home in 1924. Middletown's Triune Lodge received its charter on March 20, 1848, and its members were instrumental in having the Odd Fellows Home brought to the new west end Middletown structure from its previous housing in Philadelphia, where it had been since 1875. Guests were transferred from the old facility on July 8, 1925. It is called the Middletown Home today.

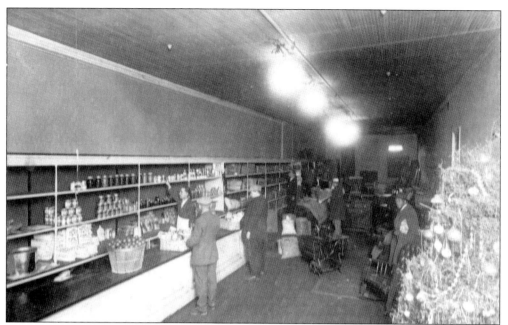

This is the American Legion Post 594 community relief food bank during a Christmas season in the early 1930s at the height of the Great Depression. It was located at 114 North Union Street, the old George King (superintendent of the Middletown Car Works) property, constructed about 1900, which the American Legion had purchased in 1922. In 1951, the Legionnaires had their own new building at 137 East High Street that they still use today.

These adults and children are at the groundbreaking ceremony for the George W. Feaser School on Race Street in 1936. Costing just over $50,000, it started out as an elementary school, was enlarged by 12 rooms in 1942 at a cost of almost $90,000, and, in 1963, was converted into a junior high for grades seven and eight. It was razed in 2008.

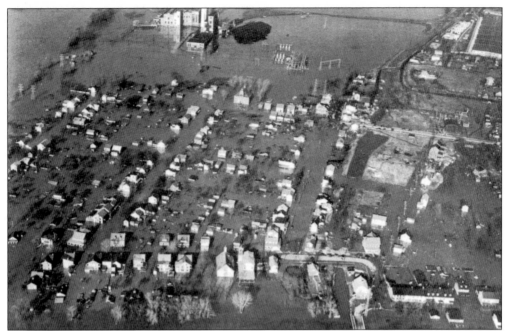

Middletown's First Ward was inundated during the St. Patrick's Day flood of 1936. The Metropolitan Edison electric-generating plant is at the top of the photograph. It continued operating at 50 percent, even with its coal-pulverizing plant out of service. The large building just below the plant to the right with the domed tower is the Susquehanna School. At the bottom center along Swatara Creek, Riverside Chapel and Rescue Hose Company No. 3 are visible side by side. (Courtesy of the Middletown Public Library.)

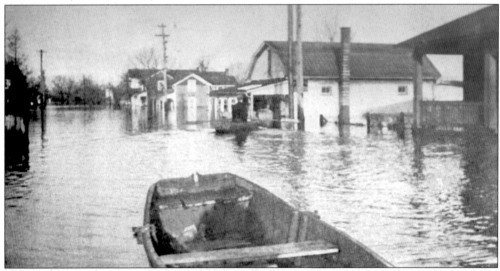

This is Penn Street in Royalton during the 1936 flood, showing Kenneth W. Klahr's grocery store. All of lower Royalton was inundated, with residents of Burd, Water, Penn, Shippen, and Canal Streets forced to leave due to water reaching second-floor levels. The only entrance to Royalton was by the Pennsylvania Railroad bridge, as the County (Grubb Street) and Aqueduct Bridges were covered with several feet of water. The flood level peaked at over 23 feet. (Courtesy of the Middletown Public Library.)

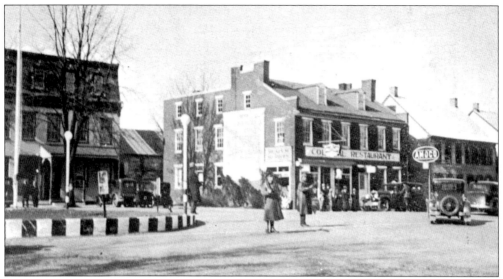

After the mid-March flood of 1936, National Guard troops were stationed at Center Square to enforce a strict quarantine put into effect on March 22. Typhoid preventative shots were given. A flood victim relief station was at the Wesley United Methodist Church at Ann and Catherine Streets, with volunteers from the Mothers Congress Circle and the Red Cross. About 200 Works Progress Administration workers arrived to help clean up afterward. (Courtesy of the Middletown Public Library.)

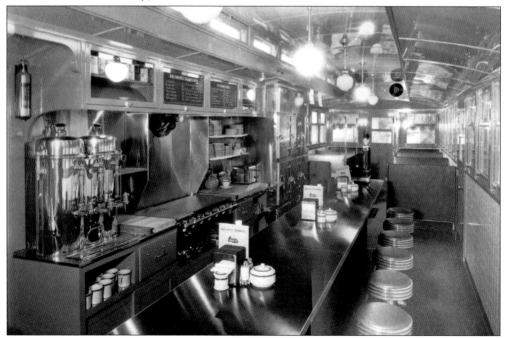

On this day in 1938, the inside of Kuppy's Diner, as usual, is spic-and-span and bright and shiny. Noticeable on the breakfast menu on the wall are two doughnuts for 5¢; orange or tomato juice, stewed prunes, or half a cantaloupe or grapefruit for 10¢; hotcakes with syrup for 15¢; two eggs, toast, and coffee for 25¢; or the "Cadillac" order—hotcakes, sausage, and coffee—for 35¢. A 15¢ tongue sandwich could also be enjoyed. (Courtesy of Karl Kupp Jr.)

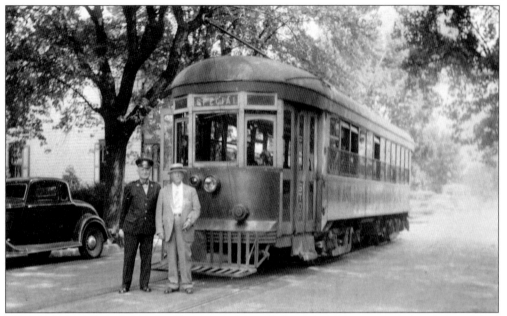

The conductor of the special trolley car and a well-dressed, cigar-toting gentleman stand and pose for this photograph on the tracks in front of the vehicle's cowcatcher. This memorable moment in Middletown's history (probably on Union Street) occurred on July 16, 1939. On the side of the trolley is a sign indicating that this was the last car run between Harrisburg and Middletown, the end of an era. (Courtesy of the Press and Journal.)

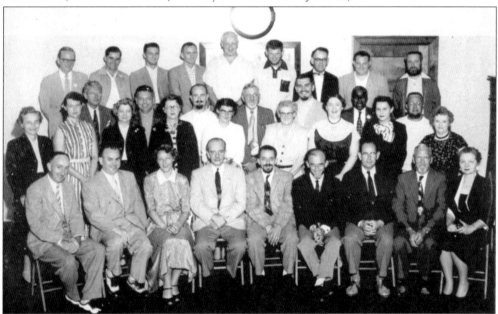

The Middletown 1955 bicentennial general committee was composed of 68 residents. Among these (not all pictured) were well-known citizens George D. Mansberger, Austin and Margaret Kern, Beane D. Klahr, George Washington Feaser, Harold Hickernell, Sara Hickernell, Rev. Julius Reeves, Paul L. Daily, John R. Brinser, Harold Romberger, Henry Fox, Harold L. Kinsey, and Harold Hummel. (Courtesy of the Middletown Public Library.)

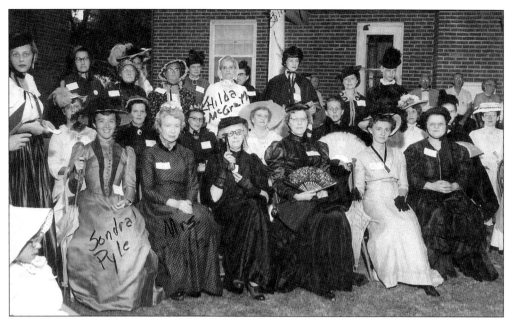

Women of Middletown dress in old-fashioned garb for this 1955 bicentennial photograph. The bicentennial celebration was held on July 9–16. A Sisters of the Swish style show and judging was held on July 14 on the St. Peter's Lutheran Church lawn. A grand historical pageant called *Middletown through the Years* was performed each night at Memorial Stadium on July 11–16, followed by a fireworks display. (Courtesy of Shirley Ray Houser Bush.)

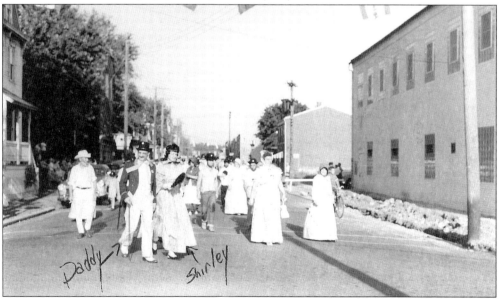

At the front of this Middletown bicentennial parade, "Daddy" is Robert M. Houser (1907–1972), president of the Middletown School Board. He is with his daughter Shirley Ray Houser Bush, who was born 1934 and is a sixth-generation descendant of George Fisher, the founder of Middletown. In addition to the Brothers of the Brush and Sisters of the Swish parade on July 11, there was a parade of antique automobiles on July 15 and the mammoth bicentennial parade on July 16. (Courtesy of Shirley Ray Houser Bush.)

www.arcadiapublishing.com

Discover books about the town where you grew up, the cities where your friends and families live, the town where your parents met, or even that retirement spot you've been dreaming about. Our Web site provides history lovers with exclusive deals, advanced notification about new titles, e-mail alerts of author events, and much more.

Find Your Place in History.